the photographer's guide to the
Maine Coast

Where to Find Perfect Shots and How to Take Them

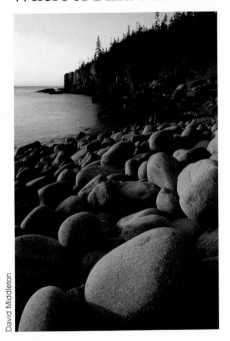

David Middleton
and Bruce H. Morrison

D1119755

THE COUNTRYMAN PRESS
WOODSTOCK, VERMONT

Library of Congress Cataloging-in-Publication Data:

Middleton, David, 1955–

 The photographer's guide to the Maine coast : where to find perfect shots and how to take them / David Middleton and Bruce Morrison.

 p. cm.

 ISBN 0-88150-535-8

 1. Atlantic Coast (Me.)—Guidebooks. 2. Atlantic Coast (Me.)—Pictoral works. 3. Photography—Maine—Atlantic Coast—Handbooks, manuals, etc. I. Morrison, Bruce, 1946– II. Title

F27.A75M53 2004

917.41'0946'022—dc22

Cover and interior design by Susan Livingston

Front cover photograph by David Middleton

Back cover and interior photographs by David Middleton and Bruce H. Morrison

Maps by Paul Woodward, © The Countryman Press

Published by The Countryman Press, P.O. Box 748, Woodstock, Vermont 05091

Distributed by W. W. Norton & Company, Inc., 500 Fifth Avenue, New York, NY 10110

Printed in Spain by Artes Graficas Toledo

10 9 8 7 6 5 4 3 2 1

Frontispiece: Otter Point, Acadia National Park

Contents

Introduction

OK, open a map of the Maine coast, and pick a spot—any spot—on the map. Now, if you were to actually go there, this is what you'll see: There is water nearby. It could be a narrow river or a piece of the coast or maybe just a lake or a farm pond, but somewhere close there is water. There are also spruce trees close by. In fact, you may be standing in a spruce forest. If you are not standing in a spruce forest, chances are you are standing in a wild meadow ringed by at least some spruces.

On the horizon you'll see either a white steeple or a shingled roof, and if you listen really hard, you'll hear either a boat's motor or a raven's call. If you walk down the road—and doubtless several will be near you—you will shortly come to a pretty New England village with a little market, a gas station, a couple of churches, and a few old stately homes with sugar maples shading their doorways. You are in a classic New England landscape.

But there is more to the Maine coast than just quintessential New England scenery. Wait, give me a minute; I'm sure I can think of something that's not quintessential. I know plenty of magnificent harbors full of colorful lobster boats and even more colorful lobstermen. I know lots of rocky points where picturesque lighthouses perch and deep spruce woods frame quiet bodies of water. And I know there are long sand beaches and beautiful villages and views that will cause your shutter to stutter. Hmm . . . OK, so shoot me; I can't think of anything on the Maine coast that isn't quintessential New England scenery. Live with it.

The best way I know to photograph the coast is to first sit back, grab a map, and read this book before you start crashing around Maine. Lots of great locations are included in this book that you'd be unlikely to find on your own—and lots of great tips on how to get your best shot. So instead of running around with Willie Nilly as your guide, pull up a chair, put your feet up, and let me make a few suggestions that just might help you get some really special shots. (Besides, Willie Nilly is a crummy navigator.)

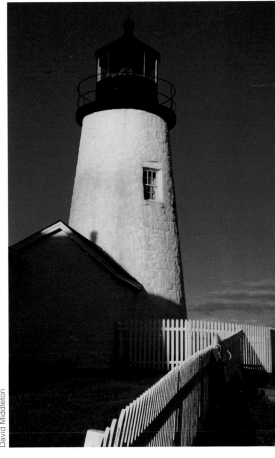

David Middleton

Pemaquid Point lighthouse

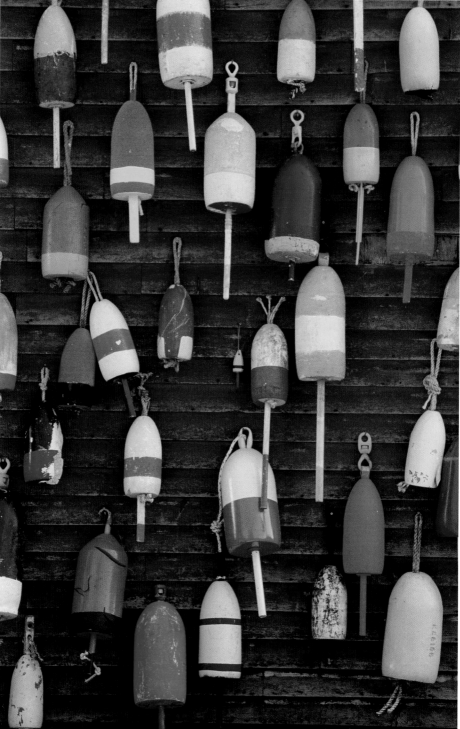

Using This Book

This book evolved out of the incessant questioning of my students about where the best places are to photograph along the Maine coast. Believing that I would actually tell them the truth, they would give me maps and blank pieces of paper, and I would describe areas and highlight roads for them to explore. But it was never that easy. There was always more to tell them and more places to suggest that they go. The Maine coast is a rich place for photographers.

The Photographer's Guide to the Maine Coast is my final answer to their questions. It includes all of my favorite places to photograph on the Maine coast. I didn't leave out any extra-secret places (at least none that you would know about), and I have included all the best-known locations. I have tried to give special attention to well-known coastal family vacation spots because those are the places that most photographers with a spare hour or two to photograph are going to find themselves.

Along with a description of each place, I have included information on when the best times might be to visit. This is done with a bit of trepidation because the seasons can vary so much from year to year, but, in general, if you go during my sug-gested times, you will find good things to photograph.

As to what to do once you get to the location, I have included some suggestions under "Pro Tips." These are what I generally do at each location and you are welcome to do the same or ignore them all together. Under "Cautions," I have given you the things you don't want to do while at the site. Some are physical things to be careful about, and some are photographic things to watch out for and avoid.

Remember that the coast is a tidal environment, so a scene that looks dreadful at high tide may look wonderful at low tide or vice versa. In other words, for every coastal location included in this book, you'll get many different looks, depending on the level of the tide. (Here's your first Pro Tip: Harbors generally look better at high tide, tidal creeks look better at midtide, and rocky coasts draped in seaweed look best at low tide.)

Most importantly, use this book to explore the Maine coast and enjoy yourself in the process. If you drive slowly and take every back road you see, you may never leave the state. Grab a map, pick a location, and have a wonderful time. You can thank me later.

How I Photograph the Maine Coast

Whenever I am photographing, I always evaluate four parameters: the light, the subject, the background, and the conditions. If all four are great—beautiful light, a pretty subject, the appropriate background, and perfect conditions—you have the potential for a great shot. If only a couple of them are great (the typical situation), you will have to work a bit harder to get a nice image, and your photographic possibilities will be much reduced.

But having less than the ideal situation to photograph doesn't mean that you shouldn't go out and shoot; it just means that you'll have to think about what you're doing. Yes, I know that thinking is the last thing that photographers want to do, but you should try it occasionally—it really helps. If you shoot everything on "program" or "automatic" mode, remember: autofocus, autoexposure, oughtaknowbetter.

Let's examine coastal Maine's light, subjects, backgrounds, and conditions and see how I can help you get better photographs. By the way, photography is photography, whether you use a drugstore point-and-shoot, an expensive Nikon, or a newfangled digital camera. It is all the process of capturing light in a pleasing way. This is how I photograph Maine.

Light

Light is the key ingredient for a good photograph. Photography is, after all, the process of capturing light on film. We all think we are out photographing landscapes or barns or children or flowers or moose, but we are actually out capturing light. If you think about the quality of the light as much as you think about the quality of your subject, your pictures will improve dramatically. If you have great light and a mediocre subject, you could end up with a great photograph; but if you have mediocre light and a great subject, you'll end up with a mediocre photograph. You'll have a chance of getting a great shot only if you have great light—but you will never have a chance of a great shot with dull light. Dull light equals a dull photograph. Write that down.

Most of the time I photograph on cloudy days and work in the office on sunny days. This is because film doesn't like strong light very much; there is just too much of it for the film to completely capture. What happens is that either the highlights are washed-out white, or the shadows are blocked-up black. The end result is a very high-contrast picture. Slide film holds the narrowest range of contrast, digital capture is a bit better, and print film is best at holding contrast, but no film will faithfully render all the light that's present on a sunny day.

I do occasionally go out and shoot on a

Bad light

sunny day. Blue skies are great for mountaintop photography, autumn color, and setting off a pretty white church. Blue skies are also great for reflections, and I will often head for water if I am out and the weather turns sunny. If you know it's going to be a sunny day, go out very early, and shoot the first few hours after sunrise. The light at this time is softer and warmer, and everything looks great in this light. The same is true for later-afternoon to sunset light.

If you are photographing any buildings with interior lights on or any cityscapes or harborscapes, the best time to do this is at twilight. Twilight is the 30 to 40 minutes before sunrise and after sunset. At this time there is just enough light to see the buildings and the scene around them, but the background will always be—no matter the weather—a beautiful dark, lavender-blue. And any interior lights add a nice warm punctuation to the image.

Cloudy days, though, are my favorite time to photograph. The range of contrast is very small when it is cloudy, so all the subtle colors that you see will be captured beautifully by the film you are using. Not all cloudy days are created equal, though. Sometimes it can be heavily cloudy, and other times it can be thinly cloudy. Given

my choice, I like thin clouds. On partly sunny/partly cloudy days when the light is varying between full sunlight, heavy cloudy light, and thin cloudy light, I wait until the sun is just behind the edge of a cloud to snap my picture. This is the thin light that is rendered best on film.

Cloudy days include rainy days, as well. In fact, my all-time-favorite light to photograph in is a light, misty rain. Before you start shaking your head, go out and try photographing in this light—you will be wonderfully surprised. You'll have both long exposures and long times to yourself in this light, but it will be worth it, trust me. Some older-generation digital cameras add visual "noise" to the image with exposures longer than 10 seconds, so beware.

If I am out, and it turns sunny unexpectedly, I usually look for reflections to photograph. Go to a colorful spot like a harbor or a market or a lake, and play with the blue sky and the mirror images you find. Blue sky is also great to do looking-straight-up photographs. Try lying on your back in a forest and shooting the treetops or lying in a meadow and shooting up at the flower—or even lying beneath a church steeple and shooting it against the blue sky. Don't lie there too long, though; they might start a service for you.

Subject

Everything you photograph has a peak time when it is at its best. It may be a barn after a fresh coat of paint or a wildflower that's fully in bloom or an autumn hillside that's fully ablaze, but everything has a day, a week, a couple of weeks when it is looking great. Ideally, this is the time when you want to photograph it. The

David Middleton

Good light

David Middleton

Fall generates a color theme

problem is that peak times are sometimes hard to find and often last for a frustratingly short period.

What to do if you have missed the peak time where you are? If you are too early in the season, either go farther south or lower in elevation. You can also try looking for your subject on seasonally earlier, south-facing hillsides. If you are too late seasonally, either go farther north or higher in elevation. You can also try looking for your subject on seasonally later, north-facing hillsides. The difference seasonally between the eastern, more northerly Maine coast and western, more southerly Maine coast and between sea level and the mountaintops can be two weeks.

The other problem with trying to predict the peak times is that they are utterly unpredictable. For the years that I have been actively photographing along the coast, the flowering times for my favorite spring wildflowers and for peak fall color have varied by as many as three weeks. My advice is to stay flexible with your intentions, and you'll always find something wonderful to photograph.

Background

Background is something that's usually overlooked, despite the fact that it is essential to the overall quality of an image. As photographers, we get so intent on our subject that we forget to consider what is behind it—yet the background will often make or break a picture. I often choose my subject based on the quality of the background, and the angle of the shot is always based on the background. If I am photographing wildlife, the background determines where I will set up, and the

background determines how I will approach the animal.

Nothing destroys a pretty portrait of an animal, person, flower, or tree like something in the background appearing to come out of the subject's head. The usual culprit is a bright stick or bright piece of grass that intersects the subject and on film merges with it. In the three-dimensional world the picture was taken in, the bright stick is well behind the flower; but in the two-dimensional world of your film, that stick is piercing your pretty flower. I have seen telephone poles coming out of Aunt Edna's head, maple branches as deer antlers, skewered butterflies, and lots of hara-kiri flowers.

It doesn't matter how magnificent your subject is, if the background is terrible, the picture will always be terrible. I diligently look for bright objects in the background. If something in your picture is brighter than your subject, it will pull attention away from it. Your eye will go to the brightest part of the image; if that is not your subject, then it becomes a distraction. Too many distractions, and your subject is lost and the image is ruined. By the way, one distraction is too many.

How do you know what your background is going to look like before you see the final image? On more sophisticated cameras, a button allows you to see what the focus of the final image is going to look like before you take the picture. This is called the depth-of-field preview button. When you push the button, the lens closes down to the f-stop you have selected, and you get to see how much of your image will or will not be in focus. In other words, you get to preview your image.

On the Maine coast the biggest back-

Bad background

Good background

ground problems are telephone lines, bright reflective metal roofs and white boat hulls, roads, and telephone lines. Did I mention telephone lines? Telephone lines can be very sneaky in Maine—especially when they sneak through the forest or span a harbor—so always be alert for them. If the distraction you detect can't be judiciously or harmlessly removed (never, ever break a branch or pull up a plant or damage anything just because it's not where you want it to be; your picture, my picture, anybody's picture is really not that important), you can try to darken the distracting background with the shadow of your camera bag, your companion, or even your own shadow. Use the self-timer on your camera, and then move around and cast your shadow behind your subject. I also carry a short length of twine in my camera bag to tie back offending branches without breaking them.

Conditions

Conditions are mostly the weather you find yourself in when out photographing, but it also includes things like your state of mind and the company you are with. Nothing is more frustrating than setting up a pretty shot and then having the wind kick up or the light change right before you are ready to shoot.

Wind is something you really can't control, so you are just going to have to be patient. I have gone through a lot of film doing long exposures when halfway through my exposure the wind decides to blow. Nothing you can do but try again. On windy days I usually head for streams, and concentrate on the moving water and the rocks.

When I am out photographing in the rain I don't use any elaborate rain covers. My camera is about as tolerant of water as I am; when I am miserable, my camera is miserable. I don't walk around with it exposed to the rain, but when it is on my tripod, I don't worry about the little moisture it's collecting. I keep a towel in my camera bag and in my car to dry it off eventually, but I don't do any other extraordinary things. When it's raining, head into the forest for your best photography. It won't be raining as hard in there, and the forest will never look better.

My same rule that applies to rain also applies to cold-weather photography: When I am too cold to photograph, my camera is, as well. If it is very cold, I carry extra batteries in my pocket to keep them warm, but that is the only precaution I take. That said, be careful when pushing your tripod into snow—the snow will force the legs even farther apart and may cause them to snap off. And though Maine's streams are very photogenic in winter, beware of the ice that's often hiding under a layer of snow.

The one Maine coast condition that you can do very little about is the wonderful insect life. The two stars of the bunch are the infamous black flies and the equally hideous mosquitoes. (Yes, I know black flies and mosquitoes are important elements of Maine's natural history. I would just prefer that they weren't part of my natural history.) Beginning in May and continuing through June (and in some high places even into July), black flies and mosquitoes can become so distracting that they will suck out all of your creative juices—not to mention your blood.

The best way to tolerate them is to learn to just tolerate them. You can try the various salves, sprays, and liquids sold at

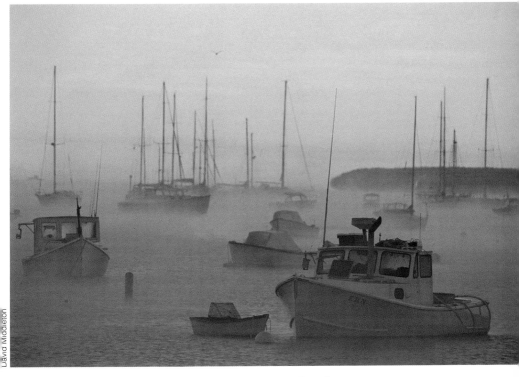

Rockport: The fog rolls in and creates an altogether new scene

every country store in the state, but insect repellants are only partially effective at best. Be careful to not get any of this goop on your gear because it can eat away at the plastic. Black flies are thickest near moving water, and mosquitoes are thickest near still water—which is about the entire state. That being said, I have seldom found these two to be so bad that they prevent me from taking a picture. They can be bad at one location and absent at the next one you go to. Just in case, wear long sleeves and long pants, a hat, and an aura of patience, and you will be just fine.

One condition that is peculiar to Maine and not to a lot of other places is the tide. There are actually many Maine coasts: There is the coast at low tide, the coast at high tide, the coast at midtide, and the

coast at all the tide levels in between. There is also the coast at extremely high tide and the coast at extremely low tide.

Each of these conditions will present a different landscape to you. What you may not like at low tide may really excite you at high tide and vice versa. And at times of an exceptionally low tide there may be things visible that are not normally or there may be access to places that are normally inaccessible. So don't write off a location just because you didn't like it the one and the only time you went there. Go again at a different tide, and you will likely be surprised at how different it is.

In general, harbors look best on a tide rising from mid to high. This is because lots of junk on the shallow harbor bottom gets exposed at low tide, which isn't very

photogenic. On the other hand the coast at low tide will have lots of rocks and ledges exposed, which can be nice for foreground interest. Just be careful of the crusty old car that's out where it doesn't belong.

Gadgets and Gizmos

All the typical stuff you normally photograph with is just about all the stuff you are going to need when you are photographing on the Maine coast. There are a few bits of equipment, though, that I find particularly handy.

Tripod: Every picture in this book—and in every book, article, or presentation I have ever done—has been taken using a tripod. Yes, I know that they are a pain in the neck to use, and, yes, I know they can be too heavy and too expensive. It's precisely because they are inconvenient to use that they are so effective. A tripod forces you to slow down and be more deliberate. It allows you to carefully consider you composition, to check the edges of your frame, to look for merges and distractions in the background. A tripod forces you to think about what you do; the more you think and are involved in the photographic process, the better your images will be.

It is best to spend a little money when you get a tripod; the cheapest ones are impossible to use. A tripod should be infinitely flexible and not fight you every step of the way. Be sure that your tripod will go flat to the ground or else you will be missing lots of wonderful shots of small critters and plants. Also be sure to get a tripod head (usually sold separately) that's easy to use and allows you to do verticals as easily as it allows you to do horizontals.

Without polarizer

Polarizing Filter: This filter, when properly rotated, has the ability to darken blue skies and lessen or even eliminate any glare from flat, shiny surfaces. I almost never use it to darken blue—polarizers have an additive aspect in that the effect you were going for appears stronger on the film than what you saw in your viewfinder. I do use a polarizer all the time on cloudy and even rainy days to cut the shine from flat surfaces such as leaves and wet rocks. It will increase your exposure by a stop or two but the enhancement of your image will be worth it.

Split Neutral-Density Filter: This is a funny-looking rectangular filter that is half dark gray and half clear. (The dark gray is the neutral-density part; the clear half is the split part.) When held up in front of your lens it can selectively darken just part of your composition. Split neutral-density filters are usually used when the foreground is in shadow and the background is sunlit. If no filter is used, either the background will look fine and the foreground will be black, or the foreground will be fine and the background will be washed-out white. Placing the gray part over the sunlit background reduces the range of contrast the film sees, prop-

With polarizer

erly exposing both the foreground and the background.

Other Filters: Don't schlock up your pictures with gimmicky filters. They are obvious, and they detract from the beauty of what you are photographing. If the light or the colors aren't what you want, just wait for a bit until they improve rather than creating something that wasn't there. Mother Nature doesn't need any help with her sunsets or rainbows or the intensity of her colors. Gimmicks never mean quality.

Diffuser: This is a foldable thin piece of material that softens—or diffuses—harsh light. It is, in essence, a cloud in a bag. A diffuser has rescued many a photo on bright, sunny days when the direct sunlight on my subject was much too harsh. (Soft, delicate subjects look best in soft, delicate light.) Most people use a diffuser by just holding it between the subject and the sun. The correct way to use it is to hold it as close to your subject as possible. The diffuser should be just barely outside your viewfinder. When you do this, the light is beautifully soft and wonderful. If the diffuser is even 10 inches farther away, the light turns to dull and is no different in quality than the light of your own shadow. Diffusers come folded up and spring open to full size. Get the largest one you can conveniently carry.

Lens Hoods: This is one piece of equipment that most people discard or put away, never to be found again as soon as they get a new lens. Shame on you! A lens hood is essential if you want to photograph in the rain (and you do want to photograph in the rain) because it keeps drops off your lens. They also act as sunshades to keep glare out of the lens. Be sure to get one that is proper for your lens or it may catch the edges of your frame and darken your corners.

Without diffuser *With diffuser*

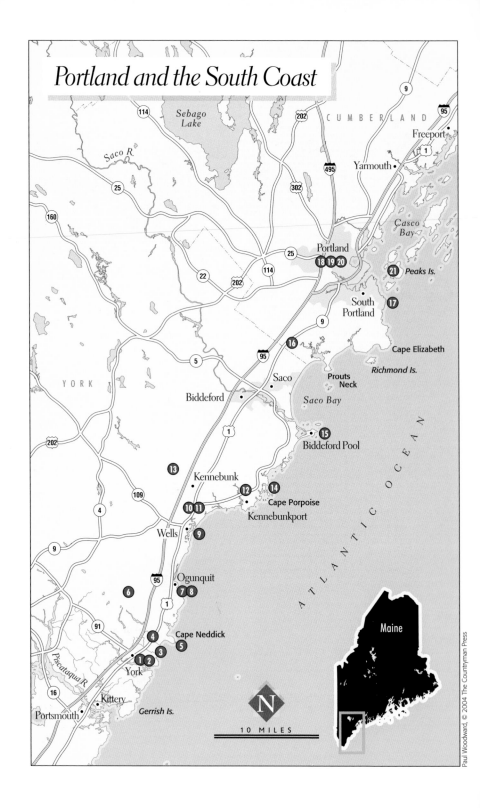

Portland and the South Coast

I. Portland and the South Coast

General Description: Most people think that the south coast is either so developed that it should be driven past or so developed that it should be driven to. Despite this perception, there is much to photograph along the south coast. You will find nice beaches (especially in the off-season), pieces of rocky coastline, small sailboat harbors, and some outstandingly scenic lighthouses.

Directions: I-95 and Route 1 parallel each other and parallel the coast from Kittery on the New Hampshire border to Portland. Don't bother with Interstate 95. Follow Route 1, despite the traffic and lights. Several roads loop off Route 1: Route 1A goes through York and Ogunquit, Route 9 goes from Kennebunkport to Saco, and Route 207/77 goes from Scarborough to Cape Elizabeth in South Portland.

Specifically: Two of the three most photogenic lighthouses are along this part of the coast—Nubble and Portland Head—and can be easily photographed. There are also nice coastal walks and quiet harbors to explore as well as several very pretty historical sites with beautiful buildings that history buffs will very much enjoy.

York Area

Old York Village (1)

This group of 18th- and 19th-century buildings, maintained by the Old York Historical Society, provides handsome examples of period architecture and is a

Where: From New Hampshire border up to and including Portland

Noted For: Sailboat harbors, beaches, salt marshes, lighthouses

Best Time: Early June

Exertion: Minimal

Peak Times: Spring: early May, Summer: June, Fall: mid-October, Winter: December

Facilities: At developed sites

Parking: In lots

Sleeps and Eats: Many in every town

Sites Included: Old York Village, Fisherman's Walk, Cliff Walk, Steedman Woods, Nubble Light (Cape Neddick), Mount Agamenticus, Perkins Cove, Marginal Way, Drakes Island Beach and Laudholm Beach, Wells National Estuarine Research Center, Rachel Carson National Wildlife Refuge, Kennebunkport, Kennebunk Plains, Cape Porpoise, East Point Sanctuary, Scarborough Marsh, Portland Head Light, Old Port, Portland Public Market, Harborwalk Trail, Casco Bay Islands

great place for photographers interested in historical photography. The buildings—open to exploration and filled with exhibits and period decorations—are clustered around a small historic cemetery, so there is much to see and photograph here.

The first building on the right is the Jefferd's Tavern, built in Wells in 1759 and moved to York in the 1930s. Situated on a nice lawn surrounded by trees, the building makes a good study of 18th-century architecture. Next door is the Old School

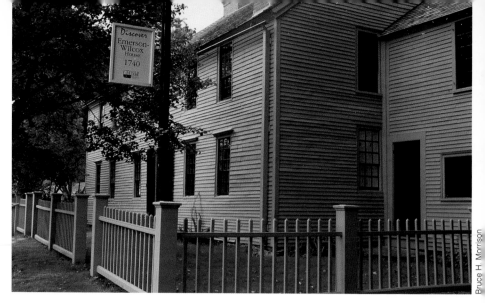

Emerson Wilcox House, Old York Village

Bruce H. Morrison

House. It is a smaller structure than the tavern and sits under tall trees, so a tripod is important here to get your best shots.

Across the street from these two structures is a colonial-era (1735) cemetery, called the Old Burying Ground, with lots of photographic possibilities. Look closely at the gravestones, and you'll be amazed at the intricate carving and the beautiful patina of age that each has acquired over the centuries. The Old Gaol (a jail) and the Emerson Wilcox buildings are found on the opposite side of the cemetery. A cannon and a pillory rest on the lawn of the Old Gaol, a structure erected in 1719.

About a mile down Lindsay Road are two more structures maintained by the society. The John Hancock Warehouse and Wharf and the George Marshall Store highlight the hustle and bustle of 18th-century life along the York River. Across the river from the wharf is the Elizabeth Perkins House, built in 1730. It is located on a beautiful lawn with gardens and fruit trees and has pretty views over the river.

Directions: Turn off Route 1 onto Route 1A in York Village. After about 0.5 mile, take a right onto Lindsay Road, which is opposite the Old First Baptist Church. The society provides parking in the small lot.

Fisherman's Walk (2), Cliff Walk (3), and Steedman Woods (4)

Fisherman's Walk, also known as the Shore Path, takes photographers along the lower York River to York Harbor. Both the river and the harbor are picturesque, so this easy stroll is a great way to find some peace and pictures when visiting the sometimes-busy York area.

Since the path is on the east side of the water, early morning will be best for photography. You will see both lobster boats and sailing yachts in the narrow, little harbor and several commercial wharves along the way. Look for piles of ropes and buoys on the piers; they make great close-up subjects.

Fisherman's Walk is about .05 mile long. The path ends at the Stage Neck Inn

at the mouth of York Harbor. On the east side of the inn is Harbor Beach, a very popular and not-so-photogenic beach. But it is a good spot to photograph a sunrise. On the east side of this small beach there is a nice walk along the rocky coast called the **Cliff Walk.** Views down to the rocks and breaking waves can be very nice, and you have a good chance of seeing seals here. You will definitely see lobster boats pulling their traps and gulls wheeling overhead. The Cliff Path is rougher than the Fisherman's Walk, so be careful whenever the trail gets close to the edge of the cliffs.

From the bridge over the York River, you can turn away from the harbor and the Fisherman's Walk, and take a nice 1-mile walk through **Steedman Woods,** which occupies the 16-acre tip of a narrow spit of land between an old millpond and the York River.

The tides can make a difference here because the wetlands are shallow and become mudflats when the tide rolls out. Low tide can afford interesting shots of marine life. When I was at the bridge in late July at low tide, mussels were clustered on the rocks beneath the bridge and shorebirds and herons were hunting in the mud.

In the woods here, photographers can find some old birch trees with peeling bark and rhododendrons ablaze with flowers in May and June. Late April and May brings lots of woodland wildflowers and also lots of mushrooms in late summer and fall after a good rain.

As you look across Lilac Lane and over Barrells Mill Pond, you'll see a small suspension bridge known as the **Wiggley Bridge** (you'll figure it out soon enough). The trail crosses this bridge (supposedly

the shortest suspension bridge in the world) and enters the woods, making an easy, level loop. You can head either way: The river is on one side, and the millpond is on the other.

Directions: From the middle of York Village, follow Route 1A south to the junction of Route 103, also called Lilac Lane. Turn right, and you'll quickly come to a bridge over the York River. The parking area for the Fisherman's Walk or Steedman Woods is on the southeast corner of the bridge. Parking for the Cliff Walk is at the Harbor Beach parking lot.

Nubble Light (5)

Properly called the Cape Neddick Light, Nubble Light, as it is better known, is perched on a small island immediately offshore of the eastern end of Cape Neddick. The light was built in 1879 and is so picturesquely set on Nubble Rock that it boggles the mind to know that this was actually a government project.

The best photography of the lighthouse is from Sophier Park at the end of Cape Neddick. A nice view is available from the end of the parking lot, or you might also want to walk out onto the rocky ledge beneath the parking area. These ledges can be included in a photo to create some foreground for the lighthouse. The late-afternoon sunlight offers the best light for this photo. Right before sunset the white buildings seem to glow from the beautiful light falling on them. The lighthouse is a silhouette at sunrise.

Directions: Cape Neddick juts out into the ocean between Long Sands Beach and Short Sands Beach in the town of York Beach. Take either Nubble Road or Broadway from Route 1A. The parking

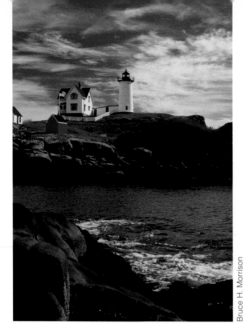

Bruce H. Morrison

The Cape Neddick Lighthouse—
better known as Nubble Light

area is well marked. That's the light in front of you.

Mount Agamenticus (6)

Mount Agamenticus isn't really much of a mountain (692 feet), but the coast is so darn flat around it that this little nubbin is a pretty big deal. From the top of the mountain visitors are greeted with great panoramic views of the surrounding countryside, the White Mountains of New Hampshire, and the coastline. As you might expect, the summit is a wonderful spot to photograph sunrise over the Atlantic Ocean.

The good news for photographers with heavy camera bags is that a road goes all the way to the top of the mountain. The good news for exercise enthusiasts is that numerous trails cover the mountain. The Blueberry Trail (off the Ring Trail) goes over nice rocky ledges with lots of views, blueberries (of course), and even

pink lady's slippers in June. If you are sick of the coast, Mount Agamenticus is a nice woodsy reprieve.

Directions: To get to Mount Agamenticus take Mountain Road 4.2 miles from Route 1 in Cape Neddick to the signed Mount Agamenticus access road. Trailhead parking is shortly on the left; the summit is about .05 mile ahead.

Ogunquit and Wells Area
Perkins Cove (7)

This very picturesque harbor is located in the south end of the little town of Ogunquit. Once a working harbor, Perkins Cove has been transformed into a center for galleries and restaurants, but the charm of the old harbor remains. It is still a very pretty spot where lobster boats and weathered fishing shacks can be found, and painters with easels are as common as gulls.

The trick is finding a place to park for this popular tourist spot. There's a small parking area that fills up rapidly; some other, more expensive, lots are within walking distance; or you can take the public trolley that travels through Ogunquit. Photographers will want to get here early, anyway, so parking shouldn't be a problem at the crack of dawn.

Directions: Access to Perkins Cove is on Shore Road in Ogunquit. Shore Road is the prettier alternative to busy Route 1. You can't miss it.

Marginal Way (8)

Marginal Way is a former cattle path along the shoreline bluffs that has now been donated and improved into a wonderful and easy coastal walk. The trail begins (or ends) at the Perkin's Cove parking area

and heads north between the shore homes and businesses and the rocks and waves of Israel Head. There are beautiful views along the entire way of beaches, cliffs, tide pools, coves, and the ocean. There are also well-placed benches along the way for people to sit and ponder the great imponderable.

The walkway stretches along the seashore for about a mile to its opposite terminus at the Sparhawk Resort on Shore Road, about a block from the center of town. If you then walk a few blocks north on Shore Road and turn right on Wharf Street, you can continue wandering on the Oceanview Path to Ogunquit Beach, about another mile ahead.

I think Marginal Way is best walked at dawn or dusk, when it's low tide—though high tide with big waves can be exciting, as well. At midday on a sunny summer day, Marginal Way is best walked with an ice cream cone in hand.

Drake Island Beach and Laudholm Beach (9)

There are miles of beautiful beaches in the Ogunquit and Wells area. The big ones are Ogunquit Beach and Wells Beach. These two get the most traffic, especially in summer, so I don't bother exploring them with my camera at that time. Off-season, especially in winter, these beaches can be wonderful, particularly after a storm.

Drake Island and Laudholm Beaches, though, are two quieter, more natural beaches that are good all year. Situated north of Wells Beach, these beaches are lovely white-sand beaches without the crowds found at Ogunquit and Wells. Abutting Drake Island Beach to the north is the Laudholm Beach. Visitors to Laudholm Beach walk from the Drakes Island Beach or hike down from the Wells Reserve (see below). Endangered Piping Plovers and Least Terns nest in the dunes

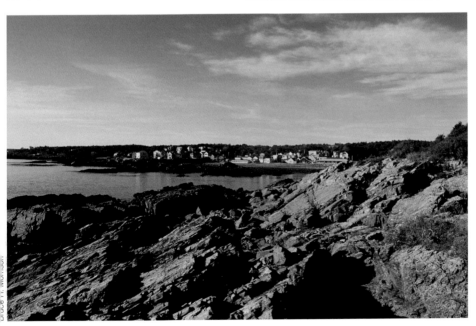

The view from Marginal Way, Ogunquit

and feed along the beach, so don't disturb them and be careful, especially during nesting season.

Directions: Turn east on Route 1, this time onto Drakes Island Road, which ends at the limited parking areas of the Drakes Island Beach.

Wells National Estuarine Research Center (10)

Locally known as the **Laudholm Farm,** this 1,500-acre facility has 7 miles of trails through fields, wetlands, beaches, and uplands. The center is a joint partnership between the state and federal government, dedicated to studying the coastal environment. The land was first farmed in the 1600s, and farming continued until the 1950s. Many old farm buildings are still standing and being used for research and educational facilities. The marvelous trail system provides beautiful views of the area and lots of opportunities to photograph everything from wildflowers to deer. It's also a wonderful birding area. An entrance fee is required in the summer.

Across the Merriland River and next door to the Laudholm Farm is the headquarters of the **Rachel Carson National Wildlife Refuge (11).** There is a short trail here but visitors are not allowed to wander on the property, so this area is of little interest to photographers. The actual refuge consists of 10 units along the coast between the New Hampshire border and Portland. It was created to protect the coastal salt marshes and estuaries, so access is difficult unless you have a canoe or you really like muck.

Directions: The center is on Laudholm Road, which is found on the east side of Route 1 about .05 mile south of the junc-

tion with Route 9. The entrance to the refuge is a bit farther down Route 9, just past the junction of Skinner Mill Road.

Kennebunkport Area

Kennebunk and Kennebunkport are popular resort towns on Maine's southern coast that are jammed with tourists during the summer months. Parking in the Kennebunkport area is nearly impossible during the tourist season, especially near the beaches. This is not a bad place to base yourself because there is much to see and do in the area for family members who are not photographers, but you will have to get out of the area to get any pictures.

Kennebunkport (12)

A stroll through Kennebunkport will provide architectural photographers with a wealth of old buildings. Sea-related industries generated most of the economy of the area from the late 1700s to mid-1800s, and some of the old homes and commercial buildings from that period still stand. The Kennebunkport Historical Society maintains five buildings that are open to the public. These buildings range from the Nott House, a Greek-Revival mansion, to an old schoolhouse and jail. The Brick Store Museum is housed in a group of 19th-century commercial buildings, and it offers midweek architectural walking tours.

The privately owned Wedding Cake House is along Route 35 between Kennebunk and Kennebunkport. This beautiful old house—once a sea captain's—was built in 1826. The South Congregational Church (built in 1824), the First Parish Unitarian Church (from the 1770s), and Graves Memorial Library (built as a bank

in 1813) are examples of early-American architecture. A ride along Ocean Avenue brings visitors to Walker Point, where the summer home of former President Bush stands.

Directions: Kennebunk straddles Route 1, and Kennebunkport is a few miles south along the coast.

Kennebunk Plains (13)

The Kennebunk Plains is a Nature Conservancy preserve that protects a sand-and-heath plain environment that is very rare in Maine. The 2,000-acre preserve provides habitat for a wide variety of unusual and regionally uncommon ground-nesting birds, including grasshopper sparrows and upland sandpipers as well as some rare wildflowers, such as the endangered northern blazing star.

The primary plants of the plains are heaths: blueberry, chokeberry, huckleberry, and bearberry. The heaths bloom in early summer, fruit in late summer, and turn a brilliant scarlet in the autumn, so there is always something to photograph. At various times some trails may be closed to protect nesting birds, but others will be open. If you are a bird photographer, bring a long lens and plenty of patience to get your best shots.

Directions: The preserve is found by turning off Route 1 in Kennebunk onto Route 9A, and then taking a quick right onto Route 99 west. The site is about 2 miles past I-95. There are small turnouts and information kiosks on both sides of the road.

Cape Porpoise (14)

The charming working harbor of Cape Porpoise has remained unspoiled, despite being so close to the summer nonsense of Kennebunkport. The pretty harbor is protected by several offshore islands, so all the views here are interesting. Lots of lobster boats are moored here, and the lobster pots that are often piled on the dock offer interesting photographs—either by themselves or as foreground for harbor shots. On a rocky ledge offshore is the **Goat Island Light.** A long (real long) lens is necessary to capture just the lighthouse, but it makes a nice background when a shorter lens is used to capture harbor images.

Directions: Cape Porpoise is off Route 9 about 2 to 3 miles east of Kennebunkport.

East Point Sanctuary (15)

East Point is at the tip of the long peninsula that defines the south end of Saco Bay. Owned by the Maine Audubon Society, this 16-acre preserve has shrubby uplands, mudflats, and rocky sea cliffs to entice visitors. A 1-mile trail leads to a point along the rocky shoreline that offers magnificent views north, east, and south over the ocean.

A good variety of birds and wildflowers are found in this sanctuary. Migrant

Bruce H. Morrison

Cape Porpoise

birds are common in the spring and fall, and great rafts of ducks are common in the winter. The north side of the sanctuary provides a grand view over Wood Island Harbor to the Wood Island Light. You'll need a long lens for this northward view of the lighthouse. A shorter lens will work if you don't want to fill up your frame with just the lighthouse.

Directions: The Sanctuary is at the end of Route 208/9 in the little village of Biddeford Pool. Turn right at both lights in town to reach the trail.

Scarborough

Scarborough Marsh (16)

Scarborough Marsh is the largest salt marsh (3,100 acres) in the state and therefore a very important site for all kinds of wildlife. During the spring and fall migration seasons, many birds congregate in the marsh, including Canada and snow geese (sometimes by the thousands) sandpipers, and ducks. In winter the marsh is a very good spot to look for—and, with a bit of luck, photograph—wintering hawks and even a snowy owl. All year, especially late or early in the day with a high tide, the marsh can be quite pretty and offers both sweeping and intimate landscapes to capture.

There are five tidal rivers that feed the marsh, so the best way to explore the area is by canoe. Alternatively, you can explore the marsh at a **nature center** operated by the Maine Audubon Society during the summer months. Or you can do both because the Society rents canoes and maintains an interpretive trail. The nature center is on Route 9 (Pine Point Road) about 1 mile south of Route 1.

Directions: The best access to the marsh is from Eastern Road as it cuts through the middle of the marsh. The 2-mile long road ends at a footbridge over the Dunstan River, from which a trail leads back to the nature center. Eastern Road turns off Route 207 (Black Point Road) about .05 mile south of Route 1 in Scarborough.

Portland Head Light (17)

I think the Portland Head Light is the most photographed light on the east coast—and deservedly so. Commissioned by George Washington, the lighthouse was completed in 1791, and it remains as beautiful now as it must have been then. One visit in any season and you will understand why this lighthouse is so famous among photographers.

The remarkable setting on a rocky ledge at the entrance to Casco Bay provides many different vantage points for photographers. Paths lead both north and south of the lighthouse, so it is possible to get great shots at both sunrise and sunset. Stop at each of the numerous viewpoints for a fresh foreground of rocks and surf that emphasize the grandeur of the building and the setting.

Directions: The lighthouse is located in the Fort Williams Park (no fee). The park is on Shore Road, which is accessed by driving north on Route 77 from Crescent Beach. Shore Road will be on the right some 1 to 2 miles from the beach.

Portland

Portland is Maine's largest city and overlooks the island-studded Casco Bay. The city offers a variety of photographic opportunities and the best way to check out the sites is on foot. The city is pretty safe

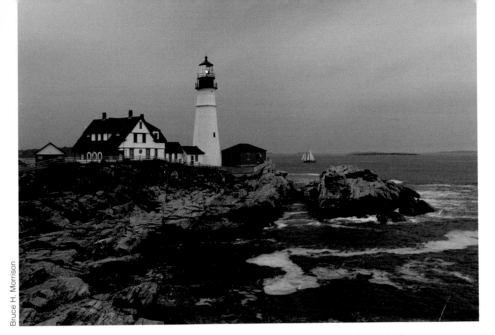

Portland Head Light, Cape Elizabeth, in operation since 1791

and there are plenty of parking areas to stash your wheels. While strolling through Portland photographers can photograph old buildings, statues, docks and marinas, shoreline, boats and gardens so even you old curmudgeons will find something you like to photograph.

As you might expect, Portland is an area rich in marine history—and it remains a working port. Freighters and cruise liners are regular visitors and can be spotted at docks in the harbor or in Casco Bay. Near the harbor is the revitalized **Old Port (18)** section of Portland. Old Port blends the new and old, with cobblestone sidewalks leading to modern bars and boutiques in the architecturally interesting historic buildings. Among the historic buildings in Old Port are the old Cus-|tom House, the Wadsworth-Longfellow House, the Morse-Libby Mansion—officially the Victoria Mansion—and the Tate House.

An offbeat place to photograph is the **Portland Public Market (19).** This wood, glass, and brick structure is located on Preble Street just west of Cumberland Avenue. A few dozen vendors sell a variety of flowers and produce plus an assortment of Maine-made products. A tripod is helpful in photographing here, but be careful not to disturb vendors or patrons.

Walking Trails

As of this writing there are 23 miles of trails in the greater Portland area, varying in length from .25 mile to over 5 miles long. Some are entirely within city parks, some link parks, several trace the harbors, and others are on the nearby islands. In other words, if you walk for pleasure or exercise (trust me, you need to walk), there's a trail or five for you in the Portland area.

My favorite walk is along the **Harborwalk Trail (20).** The trail extends along

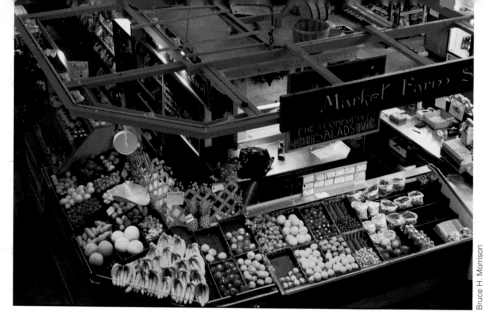

Portland Public Market

5.2 miles of waterfront and offers vistas of harbors, marinas, piers, and historic buildings. One end of the trail starts near the East End Beach, while the other end is at the Bug Light Park in South Portland. When the trail crosses the Casco Bay Bridge into South Portland, there are magnificent views of the harbor and the city and wonderful photo chances.

Another great trail is the one that circumnavigates **Peaks Island.** This 4-mile-long trail hugs the shore and provides magnificent views in all directions of the Portland skyline and the near islands of Casco Bay. The 20-minute ferry ride out to the island passes close by both Bug Light and Spring Point Light, so have your camera ready.

Speaking of islands, for more adventurous photographers it is always a worthwhile experience to take a ferry or a sea kayak and explore one or all of the 200-plus **Casco Bay islands (21).** Six main ferry-accessible islands are worth exploring: **Peaks, Great Diamond, Little Diamond, Cliff, Long Island,** and **Great Chebeague.** Peaks is the closest to Portland, Great Chebeague is the largest, Cliff is the farthest and most natural. The other islands fall somewhere in between these extremes.

These islands are the closest Portland visitors can get to what down coast looks and feels like without getting in a car and driving for several hours. Renting a bike to get around is the easiest way to see these islands. You should at least take a cruise on a pretty day to enjoy the islands from the water.

Recommendations: If you like beaches and are visiting during the summer or early fall, go to the beach as early as you can. Thirty minutes before sunrise is the time I would suggest. By 9 AM the beaches will start getting crowded, and your photographic opportunities will quickly disappear. The same applies to visiting the popular villages and trying to find park-

ing. Get there early, and don't plan to bop back for a quick shot later in the day because the parking will be gone.

The day after a storm when the weather is clearing but the waves are still big is the most dramatic time to photograph the rocky coast. Remember that the water will look leaden with cloudy skies, blue with sunny skies. Strong side lighting will make the waves look translucent, so I think the best time to shoot crashing waves is first thing in the morning or last thing in the afternoon.

Pro Tips: If you like photographing the wonderful historic buildings of this region, see if you can do so before the sites open by offering images and/or prints for their use. Sometimes this will give you special access to places visitors aren't allowed to go. Don't attach any strings to your offer—let them use your prints however they want.

The best time to photograph any scene with buildings is at twilight—the hour before sunrise and after sunset. At twilight the buildings are still visible, and all the lights inside and out add a beautiful accent to your picture. The trick is recognizing that the scene will always look better on your film than it does in your viewfinder. I don't know why this is, it just is. Don't argue with me.

Cautions: Waves are unpredictable. Just because they seem not to be getting as far as where you are standing doesn't mean a surprise is not about to roll in and drench you—or even worse, pull you out to sea. Don't get too close to the waves and become just another colorful float bobbing in the Gulf. And protect you gear from salt spray and blowing sand whenever it's windy along the coast. Screw on a sky-light or a UV filter, and keep your bag zipped up if you put it down on the sand.

Salt marshes can get a tad bit buggy in June, with mosquitoes and hideous biting flies vying for the prize of most bothersome. Slather on as much bug dope as you can tolerate but keep the vile stuff off your camera gear because it eats plastics. And be sure to tell your friends back home exactly the price you had to pay to get your wonderful shots.

Diversions: The **Ogunquit Playhouse** is billed as "America's Foremost Summer Theater," and I have no reason to doubt it. Open during the tourist season with daily performances, the playhouse is a nice way to spend a summer evening. The best **lighthouse museum** that I have seen is in the former keeper's house at Portland Head Light. Be sure to stop in after you have captured the quintessential lighthouse shot.

For more works of beauty, don't miss the **Southworth Planetarium** on the campus of the University of Southern Maine. They have special programs for children as well as the usual mind-bending star show for adult-age children.

Nearby: If you are sick and tired of this beautiful coastal stuff, head north and a bit west from anywhere along the south coast, and you'll run into Maine's **Lake District.** Sebago Lake is the biggest and most developed, but once you are in the area, you can't help but hit a lake if you drive in any direction for a few miles. The Lake District makes a nice day trip for sand-and-shore-weary photographers, but don't linger too long, or you just might start to like the area. The middle of October is when the region comes ablaze with color.

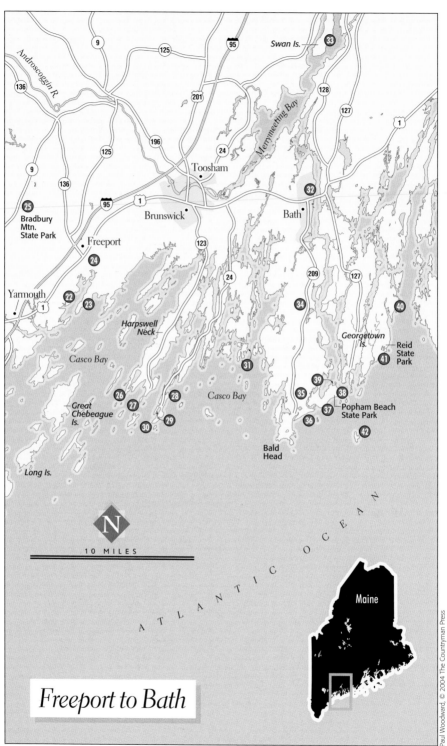

Androscoggin R.

9

125

95

Swan Is.

33

136

201

128

125

127

196

1

24

Toosham

Merrymeeting Bay

9

136

32

25
Bradbury
Mtn.
State Park

95

1

Brunswick

Bath

Freeport

123

24

209

127

24

34

40

Yarmouth

22

1

23

Harpswell
Neck

Georgetown
Is.

Reid
State
Park

Casco Bay

31

41

26

Casco Bay

35

39

Great
Chebeague
Is.

27

28

38

30

29

37

Popham Beach
State Park

36

42

Bald
Head

Long Is.

N

10 MILES

ATLANTIC OCEAN

Maine

Freeport to Bath

Paul Woodward, © 2004 The Countryman Press

II. Freeport to Bath

SEASONAL RATINGS: SPRING ★ ★ SUMMER ★ ★ ★ FALL ★ ★ ★ WINTER ★ ★

General Description: This part of the Maine coast is the closest part of the inundated coast for most visitors. Locals think the inundation is from the tourists and cite the hubbub of Freeport as sure evidence. Geographers know that the inundation is from the sea penetrating deep into the mainland, leaving the long, thin peninsulas that are so characteristic of the midcoast. The consequence of this geography is that the cities and the sophisticates are left along Route 1, and the more traditional parts of Maine are farthest down the rocky points.

Directions: Freeport is impossible to miss, with Route 1 passing through its downtown and with three exits devoted to it on Interstate 95. Just west of Brunswick, Route 1 and I-95 diverge; follow Route 1 to get to Brunswick, Bath, and beyond. The harbor villages are all accessed on mostly north-south roads that variously intersect Route 1.

Specifically: For being so close to Portland and the traffic of Route 1, a surprising amount of "old" Maine can be found here—and an even more surprising amount of truly wild Maine. Everybody seems to be rushing to get to trendy Boothbay, and they zoom past lots of wonderful places to explore and photograph. Let's keep this our little secret.

South Freeport (22)

While only 3 miles from the frenzied buying of Freeport, South Freeport seems like it's a world away. There are no streets crammed with shops and no tourists

Where: Midcoast between Casco Bay to Sheepscot Bay

Noted For: Harbors, beaches, villages, nature preserves

Best Time: Late May

Exertion: Minimal to moderate walking

Peak Times: Spring: mid-May; summer: mid-June; fall: mid-October; winter: December

Facilities: At developed sites

Parking: In lots

Sleeps and Eats: Many in Freeport, Brunswick, Bath

Sites Included: South Freeport, Wolf Neck Woods State Park, Mast Landing Sanctuary, Bradbury Mountain State Park, Basin Point, Potts Point, Bailey Island, Mackerel Cove, Lands End, Cundy's Harbor, Bath, Swan Island, Phippsburg, Morse Mountain, Sewall Beach, Popham Beach State Park, Fort Popham and Fort Baldwin, Five Islands, Reid State Park, Wildlife and Lighthouse Cruises

bumping into ice cream stands. Instead, South Freeport is a pretty collection of well-kept houses on narrow streets with nice gardens and quiet yards. In other words, this is how Freeport used to look. Come here when you can't stand Freeport a minute longer.

After you get done wandering around the village, go down to the harbor, and walk to the end of the town wharf. The main attraction in my mind to South Freeport is the little harbor in front of you. Unlike many of its neighboring harbors, this one is still a mostly working har-

Lobster traps

bor. If you are here in midday, chances are you will find a lobster boat unloading its treasure. Stay out of the way, but be sure to take some pictures of the process.

The long view across the harbor—actually, the Harraseeket River—to Casco Bay is due south, but it is due east over the wooded far side of the harbor (part of Wolf's Neck Woods State Park). It's a good picture from the wharf at sunrise, when the sun just hangs over the trees, and everything in the harbor is backlit. And don't even think about leaving without having a bite to eat at the Harraseeket Lunch and Lobster Company on the wharf. It's a well-known lunch and dinner spot for people in the know, but it is well worth the wait—especially for photographers who can happily snap away while a table is getting ready.

Directions: From the intersection of main Street and Bow Street (in front of L.L. Bean) in Freeport, follow Bow Street shortly to South Street. Turn right on South, and follow it to South Freeport Road and on to South Freeport. There are lots of signs along the way.

Wolf Neck Woods State Park (23)

Wolf Neck Woods State Park is a relatively new park, given to the state to preserve more than 200 acres of shoreline forest. There are open stands of mature white pines and eastern hemlocks in an otherwise mostly hardwood forest. On the east side the park bumps up against a salt marsh and the rocky edge of Casco Bay. The Harraseeket River defines the west side of the park.

A number of easy trails lace through the park. All are well marked and start more or less from the one and only park-

ing area in the park. The **Harraseeket Trail** leads across to the Harraseeket River, from which you can get a different view of South Freeport's harbor. The best light for photography is first thing in the morning.

Directions: Follow Bow Street from its intersection at Route 1 in front of L.L. Bean and then bear right on to Flying Point Road and right again on Wolf Neck Road. Wolf Neck State Park is at the signs not far ahead.

Mast Landing Sanctuary (24)

Mast Landing is a quiet little preserve that was once the source of tall white pines for sailing masts. This would be a good place to go if you are stuck in Freeport without a car and with a desire to get some peace and quiet. The preserve is 140 acres and has a number of trails through the salt marsh, orchard, and old field habitats. I think the best way to explore this preserve and the area downstream is with a canoe. It's only a few miles from Mast Landing down the Harraseeket River to the town wharf in South Freeport. Check the tides before you go to be sure there is enough water in this initially small creek.

Directions: Mast Landing Sanctuary in on Bow Street on the way to Wolf Neck Woods State Park. The parking area is on the right near the creek, just before the intersection of Flying Point Road.

Bradbury Mountain State Park (25)

Bradbury Mountain is a 300-acre park about 5 miles inland from Freeport. The attraction for photographers is the view from the top that stretches from Casco Bay to the White Mountains of New Hampshire on a clear day. There is an easy .05-mile-long trail from the parking area to the top of the mountain.

Directions: At Exit 20 turn away from Freeport, and go left on Durham Road. Durham Road morphs into Pownal Road and leads to Route 9 in Pownal. The park is to the right on Route 9.

The Harpswell Area

The Harpswells, as locals know them, are two long, thin arms that extend southwest from Brunswick. Route 123 runs down Harpswell Neck, the first peninsula, to South Harpswell, and Route 24, on the second peninsula, laces together Sebascodegan, Orrs, and Bailey Islands. The points of interest for photographers are at the tips of the peninsulas.

Harpswell Neck ends with three points like a pitchfork. The westernmost point, **Basin Point (26),** is the home of Dolphin Marina and Restaurant. Park well out of the way of this working boatyard, and then walk to the very end of the point. There are open views to the east, south, and west, so this is one of the few places in Maine good for both sunrises and sunsets. Basin point is at the end of Basin Point Road. The easiest way to find it is to follow the signs for the Dolphin Marina and Restaurant.

Potts Point (27) is the easternmost point of the trident. On the point are numerous brightly painted little cottages that make a nice classic Maine photograph. The area has lots of cute craft shops, as well, so it's a nice place to poke around and find a picture or two.

Bailey Island (28) is the farthermost island on the second peninsula and the only one that I think is worth lingering on for photographers. The first thing of in-

terest is the bridge that connects Orrs Island and Bailey Island. This is the only granite block cribstone bridge in the world (lets the tide go through), so if bridges cause your goose bumps to honk, be sure to have a look.

The best view of the bridge and the small cluster of lobster boats in front of it is from Cook's Lobster House, on the point due west of the bridge. The rest of the view of Harpswell Sound from Cook's is very pretty. The view is toward the north, so early and late light will be the best. The rocks in front of the Estes II Lobster House on the other side of the bridge are also very nice.

My favorite part of Bailey Island is **Mackerel Cove (29),** the large bay clearly visible from the road. The scene right from the road is very nice. The view is west, making it best in the morning. To get a closer look at Mackerel Cove, take the obvious Abner Point Road, which traces the head of the cove. There is even an official parking area at the head of the bay for your convenience. I like using the old boats and harbor paraphernalia as foreground interest. From here the view

down Mackerel Cove is southwest, so you can get some sunset color, especially late and early in the year when the sun is farthest south.

About .05 mile past Abner Point Road (still on the main island road, Route 123) is a remarkably wonderful **fishing shack** that is so perfectly placed and decorated with buoys that you'll think it is a movie set. Set out on a little point, the red shack, with the boats of Mackerel Cove behind and blue sky above—well, you can hardly go wrong. This scene is so classically Maine that your shutter won't click when your shot is taken but will instead go "ayhet."

At the very end of the road is **Land's End (30),** a gift shop and popular spot for busloads of tourists. Walk down in front of the gift shop to the rocky shore for the best picture-taking opportunities. There's a small island immediately offshore here for your compositional enjoyment. The view is mostly to the south, so avoid this spot midday.

Most of the harbors in this area are sailboat harbors. If you want a taste of a more traditional working harbor, head back toward Route 1, and on **Sebascodegan Island** turn right on Cundy's Harbor Road. As you might guess the road ends at **Cundy's Harbor (31)** (who needs a map?). Cundy's Harbor is not very big, but it is authentic, and it is appropriately remote, so there won't be tourists hanging around, looking for lighthouse coffee mugs.

The Kennebec River Area

The Kennebec River is one of the storied rivers of Maine. Flowing from Moosehead Lake in the north, it drains central Maine

David Middleton

Mackerel Cove

Downtown Bath

before joining with the Androscoggin River in Merrymeeting Bay and running to the sea. The city of Bath, once the greatest ship-building city on earth and still an important naval shipyard, is located on the Kennebec, and two of the best sand beaches in the state can be found at its mouth. It is a wonderful area for photographers and history buffs alike.

Bath (32)

The city of Bath is dominated by the Bath Iron Works, and you will surely see several naval ships in various states of construction under their huge booms. The best view is from the big new bridge over the Kennebec (or from a boat in the river).

At the base of the bridge on the north side (away from the Iron Works) is the **old part of the city,** which has been beautifully restored and is full of interesting little shops and galleries. For a nature guy I actually think it's a very pretty area. When your knickers get twisted, sit down, have a cup of something soothing, and chill.

Directions: Bath is located right on Route 1, a few miles east of Brunswick. If you see a U.S. Navy destroyer as you're driving, that's Bath in your rearview mirror.

Swan Island (33)

Swan Island is a 4-mile-long island that clogs the northeastern end of Merrymeeting Bay. It is both a Maine Wildlife Management Area and listed on the National Register of Historic Places. Once a thriving 18th-century community, it is now a little piece of historical Maine that is crawling with wildlife and wild places.

There is something for everyone on Swan Island. If you like overgrown meadows and sprawling apple trees, this is the place for you. If you are a wildlife photographer and want to get close to animals such as wood ducks, herons, and deer that are usually hard to get close to, this is the place for you. If you like historic buildings in Andrew Wyeth-like settings, this is the place for you. Quit arguing with me: This is the place for you.

The catch to all this is that access is very controlled, and it is only open to the public between May 1st and Labor Day. The state operates a small ferry that shuttles visitors to the island from Richmond. No vehicles are allowed on the island. I know this is all a pain in the neck, but being so difficult to get to is precisely the reason Swan Island is so special. Reservations are needed; call 207-547-5322. Camping is permitted.

Phippsburg (34)

Phippsburg—or as it is properly known, Phippsburg Center—is a few miles down Route 209 from Bath. This is a village that most photographers will zoom right past because they are in a hurry to get to the coast (and most of the village is just off the road), so slow down, get off your butt, and explore this beautiful little village. All you will see are huge old trees, a beautiful old white church, and a magnificently restored old inn. This is a slice of Americana pie; you will enjoy it.

Directions: On Route 209, turn on to Parker Head Road at the Phippsburg Center Store. The village is just ahead. You can get ice cream in the store.

Morse Mountain (35) and Sewall Beach (36)

OK, the official name is the Bates–Morse Mountain Conservation Area and Sewall Beach but everyone just calls it Morse Mountain or knows it as the road to Sewall (pronounced *sue-el*). Encompassing a big hunk of long-protected forest down to an entire sand beach and salt marsh, it is perhaps the wildest section of the Maine Coast between Kittery and Acadia. It is all private land, but a limited number of peo-

ple—based upon the capacity of a small parking area—are allowed to walk through it and enjoy its magnificent beauty and solitude. Remember, it is a privilege to be here, so be on your best behavior

That said, it truly is a very special place. The preserve covers about 600 acres of mature hardwood forest, with lots of hemlocks, white pines, and pitch pines plus rocky ledges to add some visual spice to the landscape. The headwater salt marshes of the little Sprague River are crossed near the beginning of the walk, and the more extensive salt marshes of the Morse River define the preserve's eastern boundary. The walk ends at Sewall Beach, an entirely wild and fully protected beach, where the endangered least tern and piping plover nest in the summer. If you have ever wondered what Maine looked like 300 years ago, this is as close as you are going to get.

You will love the area in the summer as a terrific way to escape the Great Unwashed, but you will truly fall in love with it on a rainy day in the fall or spring or on a stormy day in winter. Then you will have the entire place to yourself, and you'll never want to leave. The view from the top of Morse Mountain is very impressive for such a low hill. If the conditions aren't great for photography, put down your camera, take a deep breath, and give your soul some air. You will never forget this place.

Directions: The small parking lot at the beginning of the walking road is off Route 216, .08 mile from the Route 216/Route 209 junction.

Popham Beach State Park (37)

Popham Beach (pronounced *pop-um*) is

the developed other side of the coin compared to the wildness of Sewall Beach. Accessed by three huge parking lots, the beach is about a 100-yard walk through the dunes and pitch pines. Purple-flowering beach peach and pink and white wild rose bloom along each of the access paths in summer.

The beach itself is very impressive and is guarded by little Fox Island just offshore. You can walk to the island at low tide if you want a different perspective on the beach. The back beach area is very pretty, but it always seems like it's off limits to exploration. Let me know if you find a spot where you are allowed to wander in the dunes.

Popham Beach should be avoided on a hot summer weekend, when the crowds are unbelievable, and any nice summer day, any unusually warm fall or spring day, and any other day when it would seem like the beach is *the* place to be. But when the weather turns moody and the riffraff return to their burrows, you will probably have the beach to yourself, and the place won't seem so terrible.

Directions: Popham Beach State Park straddles Route 209, with the main entrance well signed. In the summer, just follow the aroma of Coppertone.

The Forts of Popham Beach

There are two historic forts at the end of Route 209 in the little village of Popham Beach. The first, **Fort Popham (38),** is a Civil War–era fort that is now a rough pile of granite blocks with some sense of walls and layout. It is a popular spot for fishermen and picnickers and a great spot to watch the ship traffic go by on the Kennebec River. Fort Popham is at the

Rugosa rose, Popham Beach State Park

parking area at the end of Route 209.

Fort Baldwin (39) is a World War I and World War II installation built to protect the mouth of the Kennebec River and the approaches to the Bath Iron Works. A short path leads from the parking area to Fort Baldwin Memorial Park, where a six-story tower overlooks the emplacements and has wonderful views of the mouth of the river.

Georgetown Area

Georgetown Island is at the southern tip of Route 127. At the very end of the road is the very quaint little village and harbor of **Five Islands (40),** named for the five islands that shelter the harbor. This is yet another of the forgotten working harbors that tourists and sailboats seem to never quite get to. I know there are a lot of these on the coast (thank goodness!), but each one is slightly different and therefore worth visiting with a camera and a curious spirit.

I am reminded how much I like Five Islands every time I visit. The surrounding islands make for good backgrounds for the lobster boats, and it looks due east,

so it's one of the few harbors where you can get sunrise with all the boats.

After you get done photographing Five Islands, backtrack on Route 127, and turn into **Reid State Park (41)**. Like Popham Beach, Reid State Park is most known for its beaches. The two beaches, separated by a small rocky headland, are accessible from the parking lot at the end of the park road. To the right is Half Mile Beach, and to the left is Mile Beach. As you might suspect, one is about twice as long as the other is. Half Mile Beach will be best with morning light, while Mile Beach will be best with afternoon light.

The far end of Mile Beach bumps up against **Griffith Head,** another rocky headland but higher and with a more impressive view. Griffith Head protects a little tidal creek that leads to a large salt marsh and swimming lagoon. This would be a great place to explore at high tide with a kayak or canoe. If you can catch a high tide at sunset, you should be able to get beautiful color on the lagoon with color in the sky overhead.

The reason why I particularly like this park is that it's more than just the beaches. Much of its almost 800 acres is little-visited forest and freshwater marsh. Two especially nice ponds and marshes are right alongside the entrance road. A bike path links the two, and hiking trails go behind them. These ponds are very nice in the fall for reflections and in the winter when the water freezes.

A Little Farther Afield . . .

There are 136 islands in Casco Bay, and almost every one of them makes for a worthwhile destination. You can buy a boat and tour around yourself, but it might be a wee bit easier if you rode along with one of the many **wildlife and light-**

Five Islands Harbor

house cruises **(42)** that are offered out of practically every harbor town. Some of these cruises specialize in seals, some in scenery, while others are longer and go to the far outer islands.

In general, the best whale-watching trips are ones where you spend the most time in the richest whaling grounds. Be sure to ask the operator of a whaling cruise how often whales are seen and what species are most often encountered. Pilot whales and Minke whales are the most common to see, but these species are impossible to photograph. You want to go on trips that specialize in Humpback whales. These whales are typically found near offshore banks (submerged rises), and the best whaling captains know where the nearest banks are and what the likelihood is of finding whales.

The lighthouses on this part of the coast are too far offshore for any good on-land picture taking. Several boat operators run day trips out to see **Seguin Island Light,** a pretty lighthouse but one impossible to photograph unless you are in a boat. If you are a real lighthouse enthusiast, just about any idle lobsterman will take you for a ride if you ask real nice and are ready to pay for his time and gas.

Recommendations: Where do I start? On foggy days, I head for the harbors. On bright blue-sky days (when the water is bright blue), I head for the harbors and work on reflections and classic calendar shots. When I am bored or uninspired, I head for the harbors and look for inspiration in the constantly changing scene. When do I *not* head for the harbors? On rainy days, I head for the woods—that's when the contrast is less, and the colors are the most vivid. I don't go to the har-

Beach pea, Reid State Park

bors or the beaches when it is overcast because the water and the sky turn leaden and don't look very good on film.

The busiest places, the beaches, I avoid in the summer unless it is very early in the morning, and I don't mind walking in before the gates open. The beaches are wonderful in the fall, winter, and spring—particularly the day after a clearing storm.

Pro Tips: Use a polarizing filter, especially in the woods, on a rainy day to cut the glare from all flat surfaces such as rocks, leaves, and lobster buoys. I don't use a polarizer on sunny days when I am photographing around harbors because it will make the sky too blue and also cut the pretty reflection of the colorful boats. I like using a long telephoto when I am shooting in a harbor to take pieces of the scene—such as a lobsterman unloading his catch or a gull on a bowsprit.

In summer a rim of white clouds often hangs on the horizon like a white ring on

a blue bathtub. The sky will look blue overhead but the horizon will look awful on film. Yes, there may be a hint of blue in the white clouds, just enough to seduce you into thinking it will look OK on film, but don't be fooled: It will be a blank-white sky on your film.

Cautions: There are no dangers to worry about in this part of Maine other than sudden impulses to veer into real estate offices and make outlandish offers on bits of heaven. As is always the case, beware of the level of the tide before venturing too far into the low-tide zone lest you be caught by the incoming tide and have to wade back.

The most annoying thing about the coast is the insects in June and July. There will be fewer of them on cool mornings and breezy days, but as soon as it warms up or gets calm, you may be inundated. I suggest you put things into perspective and realize that the little rascals don't really take too much of your blood—and then run like the wind to your car.

Diversions: There are three wonderful diversions on this section of the coast. I try to stop at each one on every trip I make to Maine. The first is, of course, **L.L. Bean.** This is the mothership of outdoor sports stores and lives up to all of your expectations. It is open 24 hours a day and is busiest on cloudy days in the summer, when people go shopping rather than bask on the beach. I try to go well after dinner and try to catch the helpers yawning or being understandably grumpy—never has worked, but it is fun trying. You can't help buying something, so don't fight it and buy lots of things. It will help the Maine economy.

One exit before Freeport and L.L. Bean at exit 17 on Route 95 is the world headquarters of **DeLorme,** the mapmaker of photographers. DeLorme makes state gazetteers, those really handy collections of topographic maps for an entire state. The store has all of the gazetteers and all kinds of neat map stuff, included digital plug-in things that will make your brain spin.

But the reason you should go there and bring the entire family can't be found in the store. Just inside the three-story glass entry is the world's largest, most detailed and most accurately displayed globe. This is not just any globe; this is a jaw-droppinglyastonishing globe that is both tilted appropriately and spinning on its axis appropriately. The visual result is so wondrous that you will find yourself standing in front of it and just staring at it. You are going to have to trust me on this: Go to the DeLorme store and get a big dose of wonder. It will do your heart good.

One of my favorite museums is the **Maine Maritime Museum** in Bath (just south of the Bath Iron Works). The museum covers the incredible maritime history of the Maine coast and in particular the Bath area, and is built on a former bustling boat building yard. There is more to see inside than out, so there is not much for a photographer to shoot—but there *is* plenty to keep anyone occupied for hours. A must see.

Nearby: Portland and all the photographic wonders of the area are about 15 minutes from Freeport, and Boothbay Harbor is across the narrow Sheepscot River from Five Islands.

III. Wiscasset to Damariscotta

SEASONAL RATINGS: SPRING ★ ★ SUMMER ★ ★ ★ ★ FALL ★ ★ ★ WINTER ★ ★

General Description: The land bounded by the Sheepscot River to the west, Route 1 to the north, Muscongus Bay to the east, and the Gulf of Maine to the south is not the biggest hunk of land described in this book, but it is one of the richest photographically. Maine's most photogenic lighthouse and four of the nicest harbors on the coast are found right here. You should be, too.

Directions: Wiscasset and Damariscotta are on Route 1, about halfway between Bath and Rockland. Route 27 turns south from Route 1 a few miles east of Wiscasset and drops down to Boothbay Harbor. Routes 129 and 130 head down the western side of the peninsula; Route 129 ends at Christmas Cove, and Route 130 ends at the Pemaquid lighthouse. Route 32 follows the eastern side of the peninsula from Waldoboro on Route 1 to New Harbor on Route 130.

Specifically: No matter the season, there is always something to photograph in this area. The Pemaquid lighthouse sits atop the magnificently sculpted rocky Pemaquid Point. All of the harbors in the area are full of working boats and lined with small picturesque Maine homes except Boothbay Harbor, which has been a playground for the well-heeled for more than a hundred years.

Wiscasset (43)

Wiscasset is about as picturesque a Maine village as you could create. Built upstream on the Sheepscot River, the village is small but full of stately old buildings,

Where: Midcoast, halfway between Bath and Rockland

Noted For: Harbors, villages, and a spectacular lighthouse

Best Time: Winter

Exertion: Easy walking

Peak Times: Spring: mid-May; summer: late June; fall: mid-October; winter: January

Facilities: At developed sites

Parking: In lots

Sleeps and Eats: Most in Damariscotta or Wiscasset

Sites Included: Wiscasset, Boothbay Harbor, Southport Island, Newagen, Cockolds Light, Linekin Preserve, Porter Preserve, Coastal Maine Botanical Gardens, Damariscotta, Reversing Falls, Great Salt Bay Preserve Heritage Trail, Pemaquid Point, Pemaquid Point Light, Pemaquid Harbor, Fort William Henry, New Harbor, Round Pond, South Bristol, Christmas Cove, Todd Wildlife Sanctuary, Scenic Route 213

pretty side streets, and several nice white churches. It is a classy classic.

You are going to have to slow way down here due to the heavy traffic, so you might as well stop and look around. The best view of the city and the waterfront is from the big new bridge on Route 1 that crosses the river. On the north side of the bridge there is a good view—with a longer lens—of the town and a white church steeple poking out above the trees.

Directions: When the traffic on Route 1 turns into a bumper-to-bumper crawl,

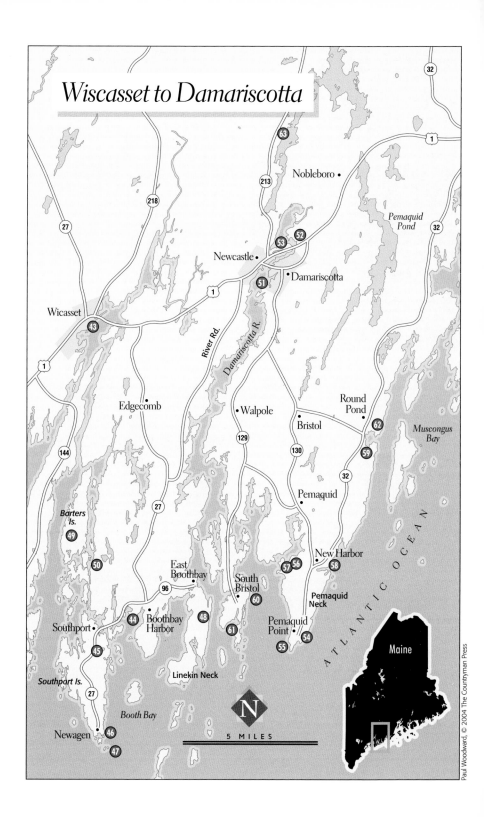

Wiscasset to Damariscotta

32

63

Nobleboro •

213

Pemaquid
Pond

218

52

32

27

53

Newcastle •

51

• Damariscotta

Wicasset

43

River Rd.

Damariscotta R.

Round
Pond

1

• Walpole

Bristol

62

Muscongus
Bay

Edgecomb •

129

59

144

130

32

Pemaquid •

Barters
Is.

49

50

East
Boothbay

57 56

New Harbor
•

58

South
Bristol

96

60

Pemaquid
Neck

48

Pemaquid
Point •

Southport •

44

Boothbay
Harbor

61

55

54

45

Linekin Neck

Southport Is.

27

N

5 MILES

Maine

Booth Bay

Newagen

46

47

Picturesque Wiscasset

chances are you are about to enter Wiscasset.

The Boothbay Area

The Boothbay Peninsula juts out into the Gulf of Maine like a giant lobster. At its head is the picturesque village of **Boothbay Harbor (44),** where million-dollar yachts mingle with one-dollar taffy. Its claws are Southport Island to the west and Linekin Neck to the east. At the claw tips are the pretty villages of Newagen to the west and Ocean Point to the east, both guarded by offshore lighthouses.

The easiest place to photograph the harbor is from the footbridge that crosses the upper harbor, but many public areas along the shore allow access to the harbor, so getting a good vantage point is pretty easy if you walk. The views from Atlantic Avenue are best in the morning, and Commercial Street is best in the afternoon.

Directions: Boothbay Harbor is 12 miles south of Route 1, between Wiscasset and Damariscotta. Don't be fooled and stop at Boothbay, which is a few miles inland from Boothbay Harbor.

Southport Island (45) is just south of Boothbay Harbor and can be reached by continuing on Route 27. The road crosses a bridge from the peninsula. At the tip of the island is the pretty little village of **Newagen (46).** Turn left to the town dock where a very small dock overlooks a small, picturesque harbor. Just offshore stands the **Cockolds Light (47).** The lighthouse can be photographed with a telephoto lens, but also makes a good backdrop of harbor images, especially at the magic light times of early morning or late afternoon.

Southport Island is mostly private and consequently offers limited photography.

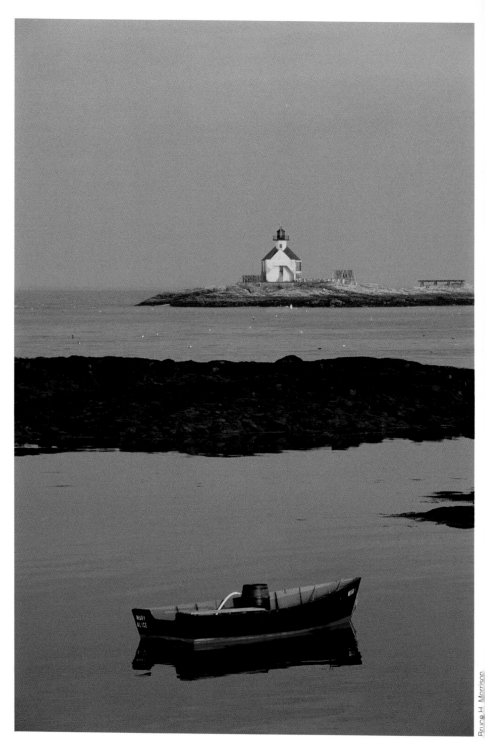

Cockholds Lighthouse, off Southport Island

The **bridge** connecting Boothbay Peninsula and Southport Island is a good sunset location. A dirt turnoff with a few parking spots is on the right on the mainland side of the bridge. This is a good location looking both east or west and for reflections off the water. When boats are moored here, they look nice silhouetted against the yellow/orange colors of sunset.

Numerous **boat tours** emanate out of Boothbay Harbor—sailing trips, whale-watching trips, and even hanging-out-with-a-lobsterman-for-a-day-trips. Intrepid photographers wanting unique images will enjoy a trip on the water to get a different view of the harbor and the nearby islands. The only good way to photograph the Burnt Island lighthouse at the head of the harbor and Ram Island Light off Ocean Point is from a boat on a harbor cruise. You can also take a ferry from Boothbay Harbor to Monhegan Island. The trip takes about 90 minutes.

Boothbay Wildlands

The Boothbay area, despite being so developed, has a surprising number of preserved natural areas. About 900 acres in 12 areas have been set aside by the Boothbay Region Land Trust (BRLT). These lands have a total of 15 miles of wonderful hiking trails for residents and visitors alike, and photographers can take advantage of these trails as they provide access to a broad diversity of the region's habitats, including forests, shoreline, wetlands, and salt marshes.

The two most popular preserves—and I think the most photogenic—are the **Linekin Preserve (48),** a 94-acre area on Route 96 south of East Boothbay that traverses the Damariscotta River; and the **Porter Preserve (49),** a 19-acre sanctuary

The view of Boothbay Harbor

on Barters Island northwest of Boothbay. Other areas include the **Colby Wildlife Preserve** on River Road in Edgecomb, **Ovens Mount East** on Dover Road Extension in Boothbay, **Singing Meadows** on Cross Point Road in Edgecomb, and the **Penny Lake Preserve** along Route 27 in Boothbay Harbor.

The Land Trust has an office at 1 Oak Street in Boothbay Harbor, where brochures of all their preserves can be obtained. If you come to the Boothbay area a lot, you might want to think about becoming a member of this organization.

Coastal Maine Botanical Gardens (50)

The Coastal Maine Botanical Gardens is a 128-acre garden of woods, meadows, and water. It is a wonderful combination of natural wildflowers and cultivated, formal gardens that is still being planted and developed. Currently daffodils and rhododendrons provide spring color near paths and entryways, while pink lady's slippers and other wildflowers blossom naturally close by.

Directions: The gardens are on Barters Island Road a little more than 1 mile from Boothbay.

Damariscotta Area

Damariscotta (51) is a pretty main street village that is part business and part fun but entirely pretty. The village is located on a harbor at the head of the Damariscotta River. Upstream from the village the river narrows and after a series of small cascades enters Salt Bay. These cascades are **reversing falls (52)**—they change directions with the coming and going tide—so if you like this sort of thing, just hang around for six hours or so and enjoy the show.

In late May and into June, when the alewives run up the river to breed (alewives are little fish; didn't want to give you the wrong impression) in Damariscotta Lake, the area around the reversing falls (and up in Damariscotta Mills) can be a magnet for feeding birds, especially ospreys, cormorants, and bald eagles. The birds are so intent on catching an easy meal that you can get very close and fill your frame with them. Look also for otters, raccoons, and great blue herons.

If watching the tide is not stimulating enough for you, the **Great Salt Bay Preserve Heritage Trail (53)** makes a very pretty loop between Salt Bay and the harbor. The trail is very easy and offers great waterside views and a chance to explore some 2,400-year-old shell middens. Anytime of the year offers a chance to see wildlife on this trail, especially great blue herons and ospreys. Bald eagles, which nest on Damariscotta Lake, are also a good possibility. The trail starts next to the post office in neighboring Newcastle.

The village of Damariscotta, like Ogunquit, Wisscasset, and Camden, has a classic New England main street: little shops in clapboard and brick buildings, flowering window boxes, and apple pies and American flags. Access to the harbor is behind the stores on the west side of town, where there's a large public parking lot and open views of the small harbor. Not many boats call this place home, but at sunset there are enough to fill your foreground. Behind the stores on the east side of town are nice streets with pretty gardens around nice homes.

Directions: Damariscotta is located just off Route 1 on Business Route 1. There are lots of signs. Routes 130 and 129 are at the south end of the village.

Pemaquid Point Area

Pemaquid Point (54) and Lighthouse (55)

Pemaquid Point is the premier rocky point on the Maine coast. Yes, I know there are lots of pretty rocky points on the coast, but once you have seen Pemaquid Point, you will know why it is so outstanding. Not only is it a large point that sticks way out into the gulf, but the rocks are a wonderful marble cake of metamorphic and igneous rocks with veins of quartz mixed with slabs of schist and gneiss. The outstanding feature of the point is a huge "frozen wave" rock formation that runs down the length of the point.

Once you pull your eyes away from the gorgeous rocks, you'll also find perfectly placed puddles for reflections, great slabs of rocks with giant blue waves crashing against them, and, in June and early July, lots of white and pink wild roses growing

in the fissures of the rocks. If you look around carefully, you can also find wild irises and lots of other little wildflowers blooming in the cracks. The general axis of the point is north-south, so there are both sunrise and sunset opportunities here—but I think sunrise is the better of the two.

Pemaquid Point Light sits at the top of the rocky point overlooking a broad expanse of beautiful Maine coast. Next to the gleaming white lighthouse is a gleaming white keeper's house, in which there is a small museum and around which is a gleaming white-picket fence protecting a small grass lawn and a couple of brick-red outbuildings, one with a very large brass bell. All in all, the combination of the picture-perfect buildings above the picture-perfect rocky point makes for a doubly picture-perfect location.

During the summer the keeper's house is open, as is the top of the lighthouse. I have seen lots of fascinating shots looking up the spiral stairs and looking out through the glass lens of the lighthouse. Be sure to wander along the coast to find more to photograph and different perspectives on the lighthouse. There are also small tide pools here that are easily accessible when the tide is out. The tide pools are also easily accessible to large and very wet waves.

Directions: Pemaquid Point and lighthouse are at the end of Route 130, about 2.5 miles beyond the junction of Route 32. There is a small parking fee during the peak summer tourist season.

Pemaquid Harbor (56)

Pemaquid Harbor is a serene harbor protected from bad weather due to its shel-

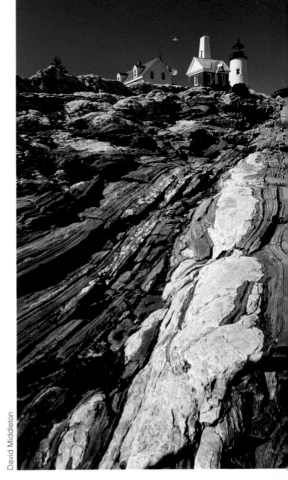

David Middleton

Pemaquid Point Lighthouse

tering coves and from summer crowds due to its off-the-beaten-path location. A nice grassy hill at the harbor access point looks east over the broad harbor. You will find mostly sailboats here, but it's such a welcome relief from the crowds nearby that you won't care.

The view is a bit better from **Fort William Henry (57),** the fourth fort built on this site to protect this important harbor. There are also remnant stone walls and a restored 1790s captain's house here to keep your lenses occupied. And a nice old cemetery in the area has lots of historical information to be digested.

The classic shot at Pemaquid Point is down on the rocks looking back up toward the lighthouse. There is almost always a puddle about halfway down the point on the west side of the "frozen wave" that allows you to get the lighthouse and the reflection of the lighthouse in your frame at the same time. Bend your knees to get lower and it will draw the reflection of the lighthouse completely into the puddle. It has been done ten thousand times before, but if you haven't done it, it is impossible to pass up. Remember, one person's cliché is someone else's best-seller.

Directions: Pemaquid Harbor and Fort William Henry are accessed at the end of Snowball Hill Road, which intersects Route 130 just south of the Route 32/Route 130 junction.

The Harbors

The four harbors of this region are all wonderful for photographers because they are all working harbors chock-full of working boats and piles of working gear, and all of them have easy access and tolerant inhabitants, so photographers are welcome. Or at least happily ignored.

New Harbor (58)

This small, narrow harbor is chockablock with lobster boats. The best place to photograph New Harbor is from Shaw's Wharf on the north side of the harbor. Because the harbor is oriented east to west, and Shaw's Wharf is in the middle, it's possible to photograph both sunrise and sunset from the wharf. I think, though, that the photography is best a few hours after sunrise and a few hours before sunset. Sunlight leaves the harbor about an hour before the sun sets.

New Harbor

There is access to the south side of New Harbor from Southside Road (no fooling around for Maine's no-nonsense street namers). There are no public access points along this road, but if you ask the home owners really nicely, you may be able to get down to the harbor. Shaw's Wharf is, by the way, where part of the movie *Message in a Bottle* was filmed.

New Harbor is also the home of Hardy Boat Cruises, which has regular service to **Monhegan Island** (see Chapter 8) and sightseeing trips around **Eastern Egg Rock,** where Atlantic Puffins have been successfully reintroduced and are easily observed and photographed from the boat. Hardy offers other sightseeing cruises along the coast, as well, as do several other boat operators in the area.

Directions: New Harbor is at the junction of Route 32 and Route 130. Shaw's Wharf is about .05 mile back up Route 32. If there is no parking at the wharf, park at the Hardy Boat Cruise's big public lot back up the road.

Round Pond (59)

Round Pond is a harbor that's easy to miss but worth the little bit of effort to find. As you might expect, the harbor is round and is once again filled with mostly working boats. The best place to photograph Round Pond harbor is from the public wharf. The view is south, so the photography is best after sunrise and before sunset. Most of the tourist traffic blows right past the harbor, so you will have the entire place to yourself.

Directions: Access to the harbor is from Backshore Road, which intersects Route 32 just north of the big brown church in town. The church is a little bit north of the intersection of Upper Pond Road and Route 32, the main intersection in the village of Round Pond.

If you are making the effort to find Round Pond Harbor, you have to stop at the Granite Hill Store on the way to the wharf. You can't miss it, and it's a wonderful little country store where you can buy everything from soaps, penny candy, and rubber boats to books and T-shirts. Don't be in such a rush. Go in and nose around.

South Bristol (60)

This is a tight little harbor built around the narrow (about 20 feet) channel between the Damariscotta River to the west and Johns River to the east. Known as the Gut, this channel marks the center of activity in South Bristol. Your activity will

likely come to a halt here because this busy passage has a swing bridge that is likely to be in operation when you are trying to get across.

Don't worry. Park your car and wander. I think the nicest part of the harbor is to the east, so it's best in the afternoon. Walk or drive to Eugley's Wharf and the Fisherman's Co-op Wharf to the east, and you will have lots to photograph. In the morning, work the west side of the harbor along Shipyard Road. Most of the boats are on the east side. The views from the Gut are best in the late afternoon.

Directions: South Bristol is near the end of Route 129.

Christmas Cove (61)

Located about 1 mile past South Bristol on Route 129, Christmas Cove is about as idyllic a harbor as I have ever found in Maine—or anywhere, for that matter. From the Christmas Cove Neck (the narrow piece of land on Route 129), you will see the harbor to the west and the rocky coast to the east. Work the harbor from all sides, but linger around the Coveside Inn and Restaurant on the south side. There you'll find good access—and even better food for summer lunches and dinner. Christmas Cove has fewer working boats, but the setting is prettier than South Bristol. Combining the two of them will give you the best of both worlds. Beyond Christmas Cove Neck there is no access to the coast.

Todd Wildlife Sanctuary (62)

The Todd Wildlife Sanctuary is an Audubon Society preserve that's a wonderful way to have a beautiful piece of the Maine coast all to yourself. A short nature trail—

the Hocomock Trail—leads through a pretty meadow full of flowers, through a spruce woods, and down to a small beach.

Across a narrow channel from the sanctuary is Hog Island, the site of Audubon's summer ecology and ornithology programs. The island is open to exploration to the public, but you will need your own boat to get there. There is usually an active bald eagle's nest on the island—and always miles of trails to explore. The view across the channel to the old boathouse on the island from the mainland dock is very nice in late afternoon.

Directions: The Todd Wildlife Sanctuary is at the end of Keene Neck Road. Keene Neck Road intersects Route 32 a few miles north of the village of Round Pond.

A Little Farther Afield . . .

Scenic Route 213 (63) is a wonderful road leading to all manner of photographic possibilities. **Damariscotta Lake** is a popular destination for summer swimmers and boaters. There is an active bald eagle nest on the south end of the lake and lots of other photographic opportunities along its convoluted, mostly wooded shores if you have a boat. If you are land-bound, go to **Damariscotta Lake State Park** on the north side of the lake to get to the water's edge. Damariscotta Lake is north of the village of Damariscotta on Route 213.

Beyond Damariscotta Lake are lots of small **New England villages** worth exploring with your camera. You will find orchards and village greens, old barns and rope swings, and plenty of intimate vistas. Check out **Damariscotta Mills, Jefferson, Washington, South Liberty** and **Cooper's Mills.** Or just start wandering,

and see what you can find. There's a very pretty church with a great view down the lake a few miles to the west of Jefferson on Route 213. I think the countryside between the villages is more interesting than the villages themselves, but I was always one who ate the middle out of Oreos. Visit both, and decide for yourself.

Recommendations: If it's foggy or sunny, head to the harbors. The fog makes for great evocative pictures, and the sun turns the water bright blue for classic calendar shots. If it's rainy or cloudy, I generally turn to the forest or to wildflowers and work on detail shots of the coast. You can shoot details of harbors in the rain, but don't include too much water because it will be rendered as dull gray on your film.

If it's windy and sunny, it's fun photographing the breaking waves at Pemaquid Point; but if it's windy and cloudy, the waves will be leaden and of no impact, so don't bother. Harbor gear doesn't blow in the wind, so if you simply *must* photograph on a windy day, look for piles of brightly colored fishing and lobstering gear.

Pro Tips: The Pemaquid Point Light looks best with blue sky behind it because it is white. I think it's best in the afternoon because the background is cleaner when looking to the east. One of my favorite compositions is to use the white picket fence in front of the lighthouse as my foreground leading to the lighthouse in the background. Often a red life ring is hanging on the fence, which adds a pretty spot of color to your picture.

Because the lighthouse is gleaming white, if you fill your frame with it, your picture will come out one or two stops

underexposed. To get the proper exposure, meter just the lighthouse, and open up (add more light to your picture) one stop if the weather is cloudy bright or two stops if there is full sunlight on the lighthouse.

Pemaquid Point is an extremely popular summer tourist spot, so the place can be crawling with people—who are always in your picture—at midday. There are far fewer people here in the fall, even fewer in the spring, and it's deserted in the winter.

Cautions: There is really nothing dangerous in this area except distracted-while-driving photographers weaving on the narrow roads. You must be careful of surprisingly large and unexpected waves around the lower rocks at Pemaquid Point. I have had several of my students show me camera bags soaked with saltwater because they were caught by a sneaky wave. And don't be heroic and try to get too close to the waves. Photo vests make crummy life jackets.

All the lobstermen in this area seem to be very friendly and tolerant of photographers, but don't just assume this and go crashing around uninvited. Always ask permission to walk down a private lane or go onto a private wharf. And be sure to send the people a print of the picture you took there when you get back home to smooth the way for future photographers.

Diversions: I have already mentioned the Granite Hill Store. If you haven't gone there yet, get yourself over there now! There are also two fascinating stores in New Harbor: Hanna's Garage—which is part garage, part hardware store, part department store, part marine supplies store—and E. E. Reilly & Sons, which is far more than just a grocery store. You

have time; go take a look around, and buy something you desperately don't need.

There are also some nice stores and galleries in Damariscotta and in Boothbay. If you like antiques, linger in Wiscasset; it is full of very nice and expensive antiques stores. Shaw's Wharf in New Harbor, the Anchor Inn in Round Pond, The Lobster Dock in Boothbay Harbor, Robinson's Wharf on Southport Island, and the Coveside Inn in Christmas Cove are great for lobsters and summer meals.

An informative museum at the Pemaquid lighthouse is usually open during the peak summer tourist hours, and there is a nice aquarium in West Boothbay Harbor, where you can touch a shark and learn all about the natural history of lobsters.

Nearby: The National Audubon Society runs a summer adult ecology camp on Hog Island. Participants learn all about the nature of the coast of Maine while seeing many beautiful and otherwise hard-to-get-to locations. The land-side operation is now the Todd Wildlife Sanctuary and is a pretty collection of fields, coastal woods, and cottages. The facilities are at the end of Keene Neck Road off Route 32, near the little village of Medomak.

Kayaks, Boothbay Harbor

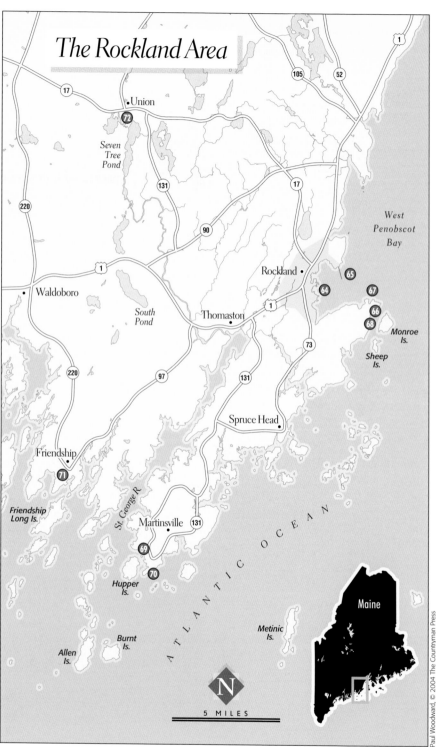

The Rockland Area

Union

72

Seven
Tree
Pond

17

131

220

90

1

Waldoboro

South
Pond

Thomaston

Rockland

West
Penobscot
Bay

17

65

64

67

66

68

1

73

Monroe
Is.

Sheep
Is.

97

131

220

Spruce Head

Friendship

71

St. George R.

Friendship
Long Is.

Martinsville

131

ATLANTIC OCEAN

69

70

Hupper
Is.

Metinic
Is.

Allen
Is.

Burnt
Is.

N

5 MILES

Maine

Paul Woodward, © 2004 The Countryman Press

IV. The Rockland Area

SEASONAL RATINGS: SPRING ★ SUMMER ★ ★ ★ FALL ★ ★ ★ WINTER ★

General Description: Caught between Muscongus Bay to the west and Penobscot Bay to the east, the Rockland area has one foot in traditional Maine and the other in sophisticated Maine. The former is represented by the waterfront villages of Friendship and Port Clyde, their protected harbors filled with colorful lobster boats and ringed by quaint little homes. The latter boasts the thriving and increasingly upscale small city of Rockland, with a renowned museum and restaurant.

Directions: Rockland sits squarely on Route 1, so you can't help but find it. When the traffic slows to a crawl, you are probably in Rockland. Port Clyde sits at the end of St. George's Peninsula and at the end of Route 131. Friendship is at the point where Route 220 out of Waldoboro and Route 97 out of South Warren merge and switch identities.

Specifically: This is lighthouse country: Of the six lights in the area, three are easily accessible and great for photography. (The other three are well offshore and require a boat to photograph.) Marshall Point Light is my favorite and one of the most popular lighthouses for photographers on the Maine coast. The Rockland Breakwater Light takes you out into the middle of Rockport Harbor, from where you can look down the coast and spot Owls Head Light perched on a high bluff with open views over Penobscot Bay.

Rockland Area

While most of the city of Rockland is not very photogenic, **Rockland Harbor (64)**

> **Where:** Midcoast on the west side of Penobscot Bay
> **Noted For:** Lighthouses, harbors, and coastal villages
> **Best Time:** Late June
> **Exertion:** Easy walking
> **Peak Times:** Spring: mid-May; summer: late June; fall: mid-October; winter: December
> **Facilities:** At developed sites
> **Parking:** In lots
> **Sleeps and Eats:** Mostly in Rockland
> **Sites Included:** Rockland Harbor, Rockland Breakwater Light, Owls Head Light, Owls Head Light State Park, Owls Head Harbor, Port Clyde, Marshall Point Light, Friendship, Union

is of great interest to photographers. A dozen or so windjammers (large multi-masted sailing vessels) call Rockland their home port, and a photographer can go for a wonderful day sail or a three- to six-day sailing adventure. You are guaranteed to get pictures that no one else has *and* have a terrific time doing it. Even if you go out for a sunset cruise, your pictures of the coast and of the boat will be stunning.

Defining the eastern edge of the harbor is a mile-long granite breakwater. At the very end of the breakwater is the **Rockland Breakwater Light (65),** a nice-looking lighthouse and lightkeeper's house that unfortunately are not in the most photogenic situation. The best angle to shoot the lighthouse is from the water, especially in the afternoon. On stormy days waves will break over the breakwater,

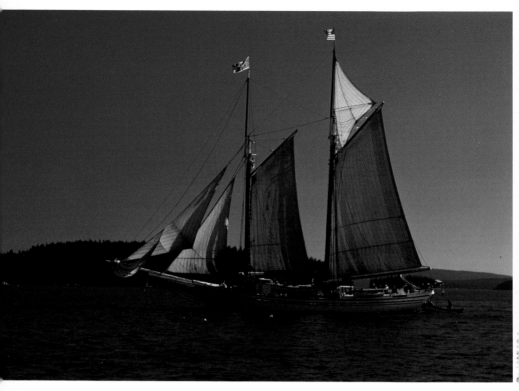

Windjammer at full sail

so keep your wits about you and your camera protected.

The photos you'll get of the lighthouse will be fine, but the real reason you will walk out to the lighthouse is not to photograph it but rather the windjammers sailing by. There is no certain time of the day when I can tell you the boats will sail by because each has its own schedule. The light in the harbor is best in the morning and then later in the afternoon. I usually check to learn if any boats are going out before I walk all the way out to the lighthouse.

Directions: Parking for the breakwater is at the end of Samoset Road, which comes off Waldo Avenue and Route 1 just north of city center. The walk out to the light on the breakwater takes about 20 minutes but is very easy.

Owls Head

Owls Head Light (66), located in Owls Head Light State Park, marks the eastern point of the greater Rockland harbor. The lighthouse is a stubby little building built into the top of a high cliff that defines the end of the Owls Head Peninsula. A long set of steps climbs up to the top of the bluff and the lighthouse, but I think the best angle to photograph the lighthouse is from the bottom of the steps. Use the steps as a strong leading line up to the lighthouse.

The lighthouse is a small part of **Owls Head Light State Park (67).** The rest of

the park is a spruce, fir, and birch forest, with several small cobble beaches. Fringing the beaches are dense clumps of wild roses and rocky outcroppings blanketed in seaweeds at low tide. Photographically, the park is best in the fog or in the fall with bright colors. You can get a clear shot at the rising sun, but there is nothing but water in your frame so it isn't one of my favorite sunrise locations.

Around the corner from the park is **Owls Head Harbor (68).** You are not going to think much of this harbor when you first see it—especially if you have been to some of the larger harbors along the coast—but my students consistently get great pictures here, so it has become one of my favorites. Walk out onto the town wharf, and you'll find lots of lobstering gear and nice views out to the harbor. Notice, in particular, the cluster of colorful rowboats tied up to the dock in front of the wharf. These make both great foregrounds and subjects for your harborscapes.

Directions: To get to the Owls Head area, take Route 73 south out of the center of Rockland to North Shore Drive. Turn left and then after a few miles left again at the little Owls Head post office and general store (a good spot for ice cream). Go down the hill, turn left again onto Lighthouse Drive, and follow it to the parking lot of the state park. The harbor is at the bottom of the hill just after the intersection of Lighthouse Drive. You can see it from the intersection.

Port Clyde (69)

Time for another confession: I love to wander around Port Clyde. It isn't the best harbor, it doesn't have the prettiest

boats, and the area is pretty small, but put together, all the odd pieces of Port Clyde add up to a wonderful whole in my mind. The fact that there's a great fresh pie and ice cream shop in town might also influence my choice.

Most people know Port Clyde as the homeport of the Monhegan boat line that runs a year-round ferry out to Monhegan Island. Photographers know it as a picturesque coastal village that is chock-full of flower gardens, piles of fishing gear, and colorful houses.

Port Clyde is a small area, so you can explore the entire place on foot. In the center of town, Route 131 (the main street) hooks around to the right and shortly ends on the south side of the back cove. Where it hooks right there's a neat old-time general store with wooden floors that creak and shelves packed with all kinds of goodies from fine wine to funky widgets.

On either side of the store are two town piers, both good places from which to photograph the harbor. The south side of the back cove is almost always stacked

David Middleton

Port Clyde cottage

with all kinds of very bright and colorful lobster pots, buoys, and piles of ropes. The north side of the back cove is the best place in Port Clyde to photograph in the late afternoon and at sunset because you get a clear view down the harbor to the west.

Directions: You can get to the north side of the back cove and the wharf there by taking Co-op Road from Route 131 on the north edge of town.

Marshall Point Light (70)

Marshall Point Light is located on the very tip of the St. George's Peninsula. This is a popular spot for photographers because the lighthouse seems to have been placed where it is by a committee of photographers. The lighthouse isn't very tall, so you won't have to worry about "keystoning"—the effect of a tall object appearing to fall away from you—as you try to get it all in your frame. Situated about 50 feet offshore on a rocky ledge that's exposed and accessible at low tide, it is connected to the land by a white wooden walkway. Immediately in front of the walkway is the keeper's house, a classic white Maine coast home with a white columned porch facing the lighthouse. A lawn and rocky shoreline stretch to either side of the lighthouse, providing views to the east, south, and west.

Behind the lighthouse is a small overgrown meadow with wildflowers in-season and a few scattered old apple trees that also make for nice photography subjects. Wild roses grow along the road and in the rocks, and flocks of eiders always seem to be offshore. Don't be fooled by the seemingly very tame duck in the little garden pool on the road into the light-

house. It is very cooperative because it is very ceramic.

Directions: Port Clyde is at the end of Route 131, a well-signed road that intersects Route 1 in Waldoboro. To get to the lighthouse, turn onto Factory Road opposite the Port Clyde Ice Cream Shop, and follow it around to Marshall Point Road. Turn right, and follow it about .05 mile to the large new parking lot at the lighthouse.

Friendship (71)

Harbor towns don't get much more picturesque than Friendship. Located on a small bay and protected by a large seaward island, the town and harbor are tucked into the landscape like a cone tucked into a holiday wreath: nicely placed but hardly noticed. Add to this setting a few of the famous Friendship Sloops in the harbor, and a photographer has everything needed for a wonderful day of picture taking.

There are two public landings in Friendship. The town wharf is in the middle of the village about .05 mile from the Routes 97/220 junction. The view here is south and mostly of just the harbor. The town landing is on the spit of land that defines the eastern edge of the harbor. From here you can shoot back to the west at the harbor or to the east over eastern Muscongus Bay.

At low tide, a gravelly "road" leads through the tidelands to a little island that sits just offshore from the landing. The island is privately owned, but the tidelands are public, so you can wander wherever you like to get your best image. The ideal situation here is to catch a sunrise or a sunset that coincides with low tide so that there will interesting stuff in your fore-

ground. Car access to the island is probably only possible an hour or two on either side of dead low tide, but foot access to the tidelands is possible at anytime during low tide. Walking around here will give you the best chance to find just the right perspective for your composition.

Directions: Two roads converge at Friendship: Route 220 drops south from Waldoboro/Route 1, and Route 97 comes in from the east from South Warren/Route 1. Where they meet in the middle of the village, Harbor Road turns off and heads for the harbor and the town wharf. One tenth of a mile back up Route 97, Bradford Point Road turns east and ends at the town landing on the eastern side of the harbor.

A Little Farther Afield . . .

If you are sick of all the beautiful things to photograph along the coast and want something different to point your camera at, drive up Route 17 to the little town of **Union (72).** This is farming country, so you'll find lots of orchards, blueberry fields, cows, barns, and sheep. Drive all the back roads you can find, and stop and talk to anyone who will listen, and you'll not only discover great things to photograph, but you will also have a wonderful time doing it.

Recommendations: If it's a screaming blue-sky day, I would head out to Marshall Point and play with the white lighthouse against the blue sky. Alternatively, it would also be fun to go to Friendship or Owls Head Harbor and play with boat reflections in the harbor. If it's anytime in the off-season, I would head to the harbors on anything other than a blue-sky day.

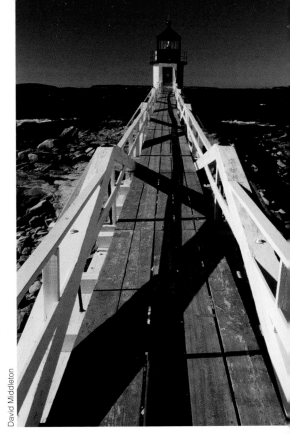

David Middleton

Marshall Point Lighthouse

Because Port Clyde and Marshall Point are so far "out to sea" compared with the rest of the coast, I would learn if there's a fog bank just offshore. I have found that it can be sunny in Rockland or along Route 1 but completely fogged in at Port Clyde. One way to tell is to listen for the offshore foghorns. The sound from the horns carries a long way, so if you're in the sun and you hear a low, consistent moan coming from the south, chances are that it's foggy out there.

Pro Tips: There are several great shots to get when you are at Marshall Point. Using a very wide-angle lens, stand at the beginning of the long walkway that leads to the lighthouse. If you bend a bit and get in

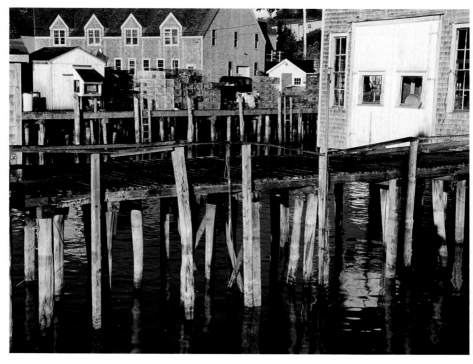

Friendship dock

real close, you should be able to fill the bottom of your frame with the converging lines of the walk and have the lighthouse at the top of your frame.

My other favorite shot is standing on the front porch of the keeper's house and framing the lighthouse between two of the white columns supporting the porch roof. This is a particularly nice shot if done very early or very late in the day when the sun seems to make the columns glow. I have also seen some very nice shots of the porch steps, especially if there is something on them like a flowering potted plant or a pumpkin.

Also at Marshall Point, see if you can wait for a lobster boat to come by behind the lighthouse before you take your shot. There's always a lot of boat traffic there, so you shouldn't have to wait too long.

Beware of white skies or even barely blue skies behind the lighthouse because on film the sky and the white lighthouse will merge together into one bland blob. You didn't come all the way to Maine to photograph bland blobs.

Cautions: Remember that real people live in these Maine coast towns, and they have real lives and real things that they need to do. Always ask permission if you want to walk on private property, and don't get in the way of people working.

In the height of summer, parking can be a problem in Port Clyde. Whatever you do, don't park in the ferry parking lot or you will be unhappy upon your return because your car will be towed away. You are going to be tempted to park there, but please resist.

Diversions: There are lots of other things to do in the Rockland area, and some of them are even fun. The **Owls Head Transportation Museum,** in Owls Head, is a world-class collection of old cars and planes, all of which are in operational condition. There are lots of things to photograph here, as well, if you like this kind of thing. An admission fee is charged to get in. There is also a small but interesting **lighthouse museum** on the first floor of the keeper's house at Marshall Point. It isn't always open, but when it is, there is much to see.

The **Farnsworth Art Museum and Wyeth Center** in downtown Rockland is a must visit for all art lovers and devotees of the Maine landscape tradition. There are five buildings here and more magnificent oil paintings than you can possibly imagine. N. C., Andrew, and Jamie Wyeth are all represented here, as well as such landscape luminaries as Winslow Homer, George Bellows, Thomas Cole, and Rockwell Kent. As a photographer, I find it fascinating to see how painters not only interpret the landscape but also compose its elements within their frame. You will be happy that you went.

Lots of interesting stores and galleries line Main Street in **downtown Rockland.** It's a good place to idle away hours of bad light or occupy long periods of lack of inspiration. There are some very good restaurants in the area including Primo, which many consider to be the best restaurant in all the Northeast.

Finally, this part of the coast seems to go gaga over holidays and fairs. Thomaston has a very fun, Norman Rockwell-type **Fourth of July parade.** Friendship has **Friendship Sloop Days** in July, when the harbor is filled with these beautiful sailboats. Rockland hosts a huge **Maine Lobster Festival** in August and a **Wooden Boat Show** in July. If you're around in late August and you really want to have fun, go to the **Union Fair and State of Maine Wild Blueberry Festival** in the little inland farming community of Union (up route 17), where there is everything from blueberry pie eating contests and pig chasing to sheep shearing to ox pulling.

Fishing gear, Port Clyde

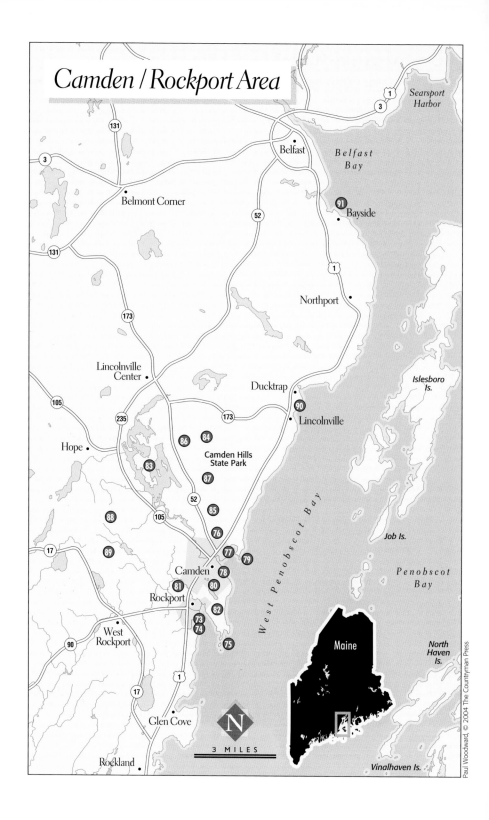

Camden / Rockport Area

Searsport
Harbor

1

3

131

3

Belfast

*Belfast
Bay*

52

91 Bayside

Belmont Corner

1

131

Northport

173

*Islesboro
Is.*

Lincolnville
Center

Ducktrap

105

235

173

90 Lincolnville

Hope

86 84

Camden Hills
State Park

West Penobscot Bay

83

87

52

Job Is.

88

85

105

*Penobscot
Bay*

17

89

76

77 79

Camden

78

81

80

Rockport

82

West
Rockport

73
74

75

90

1

Maine

*North
Haven
Is.*

17

N

Glen Cove

3 MILES

Rockland

Vinalhaven Is.

Paul Woodward, © 2004 The Countryman Press

V. Camden/Rockport Area

General Description: Camden and Rockport are midcoast sister villages with bookend harbors dotted with tall schooners and colorful lobster boats. Close behind the coastal commotion are low, rocky mountains with many easy walking paths and a beautiful lake. In the surrounding area are wonderful gardens, magnificent old inns and homes, and a historic farm with "pull-apart" cows.

Directions: The Camden/Rockport area is easily found. Route 1 passes right through "downtown" Camden as it turns north to climb around the west shore of Penobscot Bay. Rockport is cleverly hidden off of Route 1, but it adjoins Camden on the south, so it's never too far away. Take the Route 90 cutoff if you are coming from the west to avoid the traffic snarl in Rockland.

Specifically: OK, I admit it. I am in love with the Camden/Rockport area. Any photographer or fan of the Maine Coast would be. There is so much to photograph here that it almost begs its own book. You will regret leaving, but you will be back. Trust me.

Rockport Area

Rockport (73) is the shy sister of bigger, more cosmopolitan Camden. While most people head directly to the picturesque harbor when they come to Rockport, there are things to photograph in the village, as well. The homes along Pascal, Central, and Mechanic Streets are very pretty and have very nice dooryards and

Where: Midcoast on the west side of Penobscot Bay
Noted For: Harbor, schooners, villages, mountains
Best Time: Late June
Exertion: Minimal to moderate hiking
Peak Times: Spring: mid-May; summer: late June; fall: mid-October; winter: December
Facilities: At developed sites
Parking: In lots
Sleeps and Eats: Many in Camden
Sites Included: Rockport, Rockport Harbor, Beauchamp Point, Camden, Camden Harbor, Laite Beach, Windjammer Cruises, Belted Galloways and Aldermere Farm, Merryspring, Children's Chapel, Fernald's Neck Preserve, Camden Hills State Park, Mount Battie, Maiden Cliff, Mount Megunticook, Bald Mountain, Camden Snow Bowl, Lincolnville Beach, Bayside

gardens, many with flowers poking through white-picket fences. Rockport is much quieter than Camden, so you are likely to be the only one wandering the streets here. Remember to ask permission if you decide to get too intimate with a person's property.

The primary attraction to Rockport is the harbor. Unlike its flashier sister harbor around the bend in Camden, **Rockport Harbor (74)** is much more serene and much less commercial. There are two access points to the harbor, but they are connected by a footbridge, so where you end up parking is really not so important. The "working" side of the har-

bor is accessed from the unnamed street that cuts steeply downhill on the west side of the old brick Union Hall. At the bottom of the hill you'll find a small parking lot and the head of the harbor. Be sure not to park in the reserved spaces, and don't get in the way of the workings going on around you.

If you don't feel like being in the way of people actually making a living, on the other side of the little creek at the head of the harbor is the official public parking area for Rockport Harbor. An unnamed access road to this side of the harbor is the first road on the left as you cross the bridge in Rockport heading south. If you enter Rockport from the south, the turn on to this road is too sharp to make, so you'll have to cross the bridge ahead of you, buy a book at Tim Whelan's shop, and turn around and approach the turn from the north.

From either parking area the harbor is very pretty. You will be looking due south, so other than the middle of the day you'll probably get interesting light. Don't overlook the details of the harbor at your feet. There are often pretty wooden boats to photograph and flowers on the hillside. And don't be afraid to use a telephoto lens to reach out and capture pieces of the scene in front of you. If you arrive early on a foggy morning, realize that you will be photographing a small slice of heaven here on Earth.

If you go to the end of Mechanic Street (on the east side of the harbor), the paved road turns to a good graded gravel road and enters a nice patch of **hardwood forest** as it circles **Beauchamp Point (75)**. The road, now called Beauchamp Point Road, eventually heads back toward Camden, but the first half mile of the road

on the Rockport side is the wildest. These woods are a good place for foggy-day photography, spring wildflowers, and fall color. Where the road takes a zig and a zag, there's an informal parking area on the waterside and a short path down to some **harborside rocks.** This is a popular summer swimming spot for locals, and it's also the best place to photograph Rockport Harbor at sunset.

Camden Area

Camden (76) is the main tourist destination on the midcoast of Maine. To me, Camden manages to be vibrant without being cheesy. Camden is Bar Harbor without all the T-shirt shops and Kennebunkport without the attitude. OK, I am biased—but with good reason. I have never been disappointed with camera in hand in Camden.

The village of Camden mostly stretches along Route 1, and on summer weekends the traffic can be a bit maddening. But if you park your car and walk, or if you drive the side streets, you'll find far less traffic and far more to photograph. Along Route 1 (called Elm Street on the south side of town, Main Street in the middle of town, and High Street on the north side of town) are lots of beautiful homes and businesses with bright gardens and pretty architecture. The big old inns are mostly clustered on High Street, while the bustling commercial part of town is a three-block section of Main Street. Despite my affection for flowers and forests, I enjoy grabbing my camera and wandering Main Street, looking for fun shots to take.

The place for photographers to spend most of their time while in Camden is at the **harbor (77).** This is not just any

Camden garden

Camden Harbor at sunset

the most traditional, nor is it the quaintest or even the prettiest on the coast, but it's got a panache not found in other Maine harbors. Although some old-timers don't think panache belongs in a Maine harbor, I happen to like it in Camden. Just don't let it get on your clothing; it is impossible to get out.

The access point for the harbor is the large public parking lot at the foot of Commercial Street (follow the public parking signs) at the head of the harbor. From the lot you can gain access to the schooners tied up on the docks and walk along the harbor's edge to see the other boats. Along the back edge of the lot, the Megunticook River empties into the harbor in a series of falls and cascades that can be pretty when the water is running high. Beware of trash carelessly tossed in the water that gets stranded on the rocks and then sneaks into your pictures.

The best overall view of the harbor is from the lawn of the **Camden Library** on the other side of the river from the public parking lot. In the morning and in the afternoon (but not at midday) the view down the length of the harbor is magnificent. If you can catch one of the schooners going out, it's even better. The library is about a four-minute walk from the lot.

Another nice view of the harbor is from **Laite Beach (78)** (pronounced *late*), which is along Bayview Street, the road with all the restaurants and shops that parallels the harbor. From Bayview Street, Laite Beach looks like a small park, but there is actually a little swimming beach and big view of the harbor. You will be looking east, so the best time to go to Laite Beach to photograph the harbor is in the afternoon. Laite Beach is about a five-minute walk from the public parking lot.

harbor, though. This harbor is quite narrow, and in the summer it's packed with boats—everything from traditional lobster boats and simple sailboats to million-dollar yachts and large two-masted schooners. In other words, there is much to see and photograph in the harbor. The more time you spend looking, the more you will see.

But the allure of the harbor is more than just the boats. Camden Harbor is to all other Maine harbors what Notre Dame is to all other churches. The harbor is not

Another way to get a view of the harbor and all the harbors and islands in the area is to take a trip on one of the dozen or so large schooners—known locally as windjammers—stationed in the Camden and Rockport harbors. These beautiful and often historic boats go out and cruise the coast, allowing for innumerable opportunities for unique photos. Depending on the boat, **windjammer cruises (79)** vary between afternoon and sunset trips to multiple-day trips. Most of the boats supply gourmet meals and are crewed by very knowledgeable and very nice people—dare I say characters?—enhancements to any trip.

Belted Galloways and Aldermere Farm (80)

When you have had enough of harbors (is that possible?) and you want to photograph something else, there are lots of other places to go near Camden. One of my favorite things to do is to go see the famous Belted Galloways. These cows have become so identified with Camden that their likeness is almost its unofficial logo. These are not just ordinary cows, though; these cows are adorable.

Belted Galloways are cows that are black fore and aft and white amidships, looking rather like very large Oreo cookies with stubby legs and wet noses. I like to call them "pull-apart cows," for obvious reasons, but you can call them whatever you like. The other part of the photographic appeal is where they live. Old stone walls border the pastures and large spreading maples shade the edges. Across the main pasture a little lake—known locally as the Lily Pond—makes a nice background for this beautiful pastoral setting. This is part of the Aldermere

Farm, and it is so pretty (and unusual) that it is overseen now by the Maine Coast Heritage Trust.

There are pastures on both sides of the road so you can photograph the cows with either morning or afternoon light. Baby Belted Galloways romp in the fields beginning in mid-June. If you catch a foggy day, and the cows are close to the road, take a few shots for me and then a few more; they will be wonderful.

Directions: To get to the farm from Camden, take either Bayview Street or Chestnut Street (which intersect Route 1 at the big white church in town), and follow them toward Rockport. Bayview merges with Chestnut about a quarter of a mile before the farm. From Rockport, bear right off Central Street at the Rockport Library onto Russell Avenue, and follow Russell to the cows. Russell and Chestnut are the same road but with different names depending on where you start. Welcome to Maine!

Children's Chapel (81) and Merryspring (82)

If you like gardens, two in the area are worth exploring. The first one, known locally as the Children's Chapel, is a formal garden with a beautiful little chapel tucked into a hill. This peaceful place has flowers and ornamental plantings in bloom from May through September, but it is worthwhile to go any time of the year.

The chapel is on Beauchamp Point at the intersection of Calderwood Road and Chapel Road. There are no street signs, so names here are not going to help you much. Calderwood intersects Chestnut Street on the Rockport side of the Belted Galloway farm. You'll know you're on the

right road if you drive through a golf course. Where the golf course ends and a gravel road intersects on the right, this is Chapel Road. The entrance to the Children's Chapel is immediately on your left. It is .05 mile from Chestnut Street to Chapel Road.

The other pretty garden in the area is Merryspring, a horticultural nature park. This garden is less formal but more packed with flowers than the gardens at the Children's Chapel, and it has a little visitors center to help you. I go to Merryspring on misty rainy summer days when no one else is there, and the flowers are looking great. To get to the garden, turn off Route 1 onto Conway Road at the Subway sandwich shop just outside of Camden on the south side of town. Merryspring is at the end of Conway Road.

Fernald's Neck Preserve (83)

A few places inshore from Camden and Rockport offer relief from the mind-numbing beauty of the coast. Fernald's Neck Preserve, owned by The Nature Conservancy, occupies most of a large arm that extends into Lake Megunticook. The first part of the preserve is a nice overgrown field that has lovely meadow wildflowers and some lakeshore frontage. The rest of the preserve is a mixture of white pines, mature hardwoods, and a couple of small bogs with shoreline rocks and some small shoreline cliffs to add a bit of drama.

The preserve is laced with trails, and you are likely to have the place entirely to yourself—especially in spring, fall, and winter. In summer parts of the shore become popular swimming spots, but even then the interior will be empty. The best wildflowers are from mid-April to mid-

May in the forest and in July and August in the meadow. The woods can be amazingly buggy in June, so beware.

Directions: To get to Fernald's Neck, take Route 52 from Route 1 on the north side of Camden (opposite the Library) and follow it 4.6 miles to Fernald's Neck Road on the left. Follow this road for about 1 mile, bearing left at the fork to the preserve parking lot behind the pretty farmhouse. Fernald's Neck road is .02 mile past the Youngtown Inn on Route 52.

Camden Hills State Park

One and a half miles north of town on Route 1 is the main entrance to **Camden Hills State Park (84).** To the right is the camping area and access to the bay but not much of interest to the photographer. To the left, past the entrance station, is the short, paved road that climbs to the top of **Mount Battie (85).** This is where most photographers will want to go. From the open rocky top of Mount Battie almost the entire midcoast of Maine is visible. Especially prominent at the foot of the mountain are Camden and its harbor, allowing a bird's-eye view of this pretty landscape. And in early June I have found pink lady's slippers in bloom in the woods on top of Mount Battie.

There are a couple of other nice hikes within the state park. A short but steep trail leads from the shore of Lake Megunticook to the top of the 800-foot-tall **Maiden Cliff (86).** This is another one of those spots where legend has it a heartbroken maiden leaped to her death because she was tragically spurned. For all the legendary leaping maidens in New England, it makes you think twice about walking under a cliff. Once you get flying

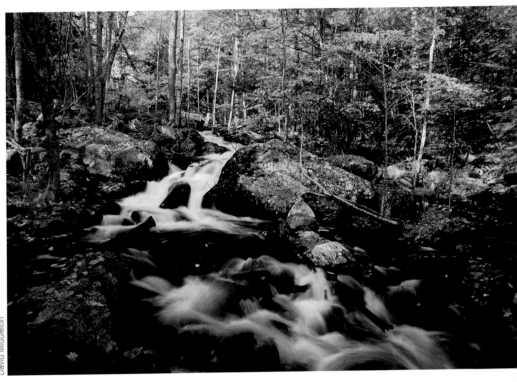

Camden Hills State Park

maidens out of your mind, notice the magnificent view of the lake spread out at your feet. The view looks west, so it is best in the morning. The trail continues on for another 2 miles through forests and outcroppings to the top of **Mount Megunticook (87),** with its 360-degree views. The trailhead to Maiden Cliff is on Route 52, 2.7 miles from its intersection with Route 1 in Camden.

Bald Mountain (88) and the Camden Snow Bowl (89)

For an easier hike with equally impressive views and fewer people, continue on Route 52 to the Youngtown Inn, and turn right on Youngtown Road. In 2.6 miles Youngtown Road intersects Route 73. At this intersection there's a parking lot tucked into the woods and a trailhead that leads up to Bald Mountain. The only views you will get are from the open top of this low mountain, but it's a fairly easy walk, and it wouldn't kill you to get some exercise. The view over Penobscot Bay is to the east, so it's best in the afternoon or at sunrise if you can get up—and up there—early enough.

The Camden Snow Bowl is the little ski area just outside of town. I usually wander over there in the summer to explore the fields of meadow flowers, and it can be very pretty in the fall, as well. **Hosmer Pond** is right next door and is also worth a look or two. The easiest way to get to the Snow Bowl is to turn west onto Main Street from Route 1 at the large Maine Sports Store. Follow Main Street

until it ends at Hosmer Pond Road, and turn right. The Snow Bowl will be shortly ahead on the left.

A Little Farther Afield . . .

The best sunrise in the area is at **Lincolnville Beach (90),** 4 miles north of Camden on Route 1. This is one of the few spots on the midcoast with clear eastern views and lobster boats in the foreground for a bit of photographic interest. Incidentally, Lincolnville Beach is the place where you catch the ferry over to **Islesboro.** Set up near the ferry dock and the moored lobster boats for the best sunrise compositions. The best time to photograph here is at low tide because in addition to lobster boats, you can also get nice foregrounds from the exposed rocks on the beach.

If you want to wander around in a time warp, continue up Route 1, and follow the signs to the picturesque hamlet of **Bayside (91).** Started as a Wesleyan summer campground, Bayside grew to a summer community of a hundred or so little gingerbread cottages tightly arranged around spreading maples and sprawling flower gardens. The amazing thing about Bayside is that it stopped growing and developing 100 years ago. Now, the picture-perfect little cottages are a scene out of time, like a movie set, with more photo opportunities than you can shake an apple pie at. There is also a pretty little harbor below the village green. Don't be embarrassed if you start saying "golly, gee-whiz" a lot. Bayside is one of the few places where such comments are encouraged.

Directions: Bayside is 16 miles north of Camden and 3 miles south of Belfast. The turn off Route 1 is marked, but it's easier to look for the Bayside Store on Route 1. The turn onto George Street, with three stop signs, is just north of the store toward the water. George Street turns into Shore Drive and follows the coast south. The main cluster of cottages starts a block east of George Street along Broadway. Just park where you can, and explore by walking. Wonderment is around every corner.

Recommendations: Where do I start? On foggy days, I head for the harbors. On bright blue-sky days (when the water is bright blue), I head for the harbors and work on reflections and classic calendar shots. When I am bored or uninspired, I head for the harbors and look for inspiration in the constantly changing scene. When do I not head for the harbors? On rainy days, I head for the woods, when the contrast is less and the colors are the most vivid. I don't go to the harbors when it is overcast because the water turns leaden and doesn't look very good on film.

Pro Tips: Use a polarizing filter—especially in the woods—on a rainy day to cut the glare from all flat surfaces such as rocks, leaves, and lobster buoys. I don't use a polarizer on sunny days when I am photographing around harbors because it will make the sky too blue and cut the pretty reflection of the colorful boats. I like using a long telephoto when I'm shooting in a harbor to take pieces of the scene, such as a lobsterman unloading his catch or a gull on a bowsprit.

The views from all the mountaintop lookouts are distant enough so that you will want to use at least a 200mm lens to draw in the scene. A tight shot of just the harbor is best with a 300mm lens. If you ask nicely at the Camden Hills State Park

Entrance Station, you can sometimes get permission to drive up Mount Battie before the gate officially opens. Bring the gatekeeper a treat as a thank you.

Cautions: There are no real dangers in the area, other than especially energetic meter readers and distracted out-of-state drivers. Remember to ask permission before you start pointing your camera at someone's home or getting in the way of people working. Most of the harbor people are very nice and tolerant of the antics of photographers, but a few have had unpleasant experiences, so be very nice and send them a print of the picture you took of them or their boat if you can.

If you are visiting during bug season (June), anywhere you go in the woods away from the coast will be bad with mosquitoes and black flies. This is especially true for the Fernald's Neck Preserve. The catch is that June is often a great time to be in the woods. I have no solutions that don't require more discomfort than I would like to admit. Suffering does seem to heighten all experiences, though. Good luck!

Diversions: Two places in Rockport are of primary interest to photographers of all sorts. The first is **Maine Photographic Workshops,** the oldest and most prestigious photography-and-film workshop company in the country. The workshops offer classes in all aspects of film and photography from directing, digital, nature, hand coloring, and postproduction. The office is in the old brick building, Union Hall, on the corner of Central Street and the access road down to the harbor. They have a nice store, the Resource, next door. Rockport College, an adjunct of the workshops that offers one- and two-year pro-

fessional degrees and an MFA program, is also based here. The main campus of the workshops and Rockport College is a short walk away. Ask for directions at Union Hall.

The other place of interest to all photographers is **Tim Whelan's Photography Bookstore.** Tim has the best selection of photo books I have ever seen, anywhere. New books and hard to find out-of-print books are all here, and Tim is a font of information. Go in and buy another copy of this book and my other books on Vermont, and say hi to Tim.

Nearby: If you are a wandering spirit, it's usually profitable to drive inland from the coast and look for things to photograph. I usually drive the road to Hope (mostly because that sounds like a thing I should be doing) and then continue on to the little village of Appleton, taking all the back roads I can find. A number of low, treeless ridges in this area are blueberry balds, which make nice subjects—especially in October, when the blueberry plants turn crimson.

Bayside

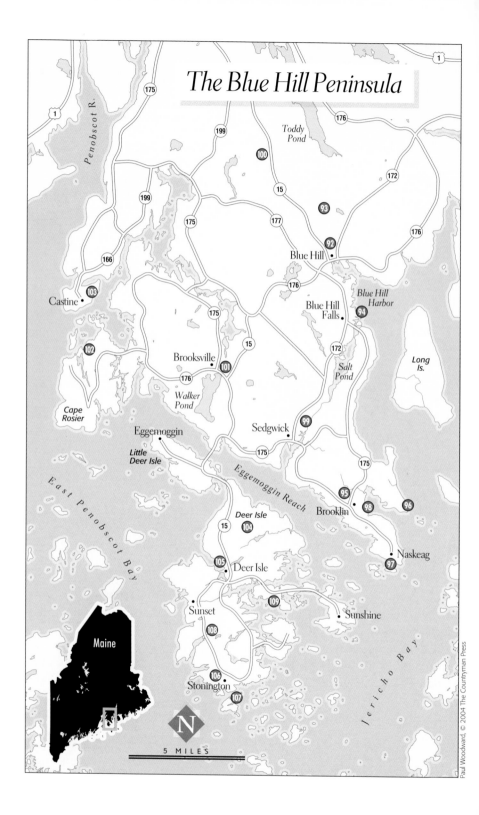

The Blue Hill Peninsula

Penobscot R.

Toddy Pond

Blue Hill

Blue Hill Harbor

Blue Hill Falls

Salt Pond

Long Is.

Castine

Cape Rosier

Brooksville

Walker Pond

Sedgwick

Eggemoggin

Little Deer Isle

Eggemoggin Reach

East Penobscot Bay

Brooklin

Naskeag

Deer Isle

Deer Isle

Sunshine

Sunset

Stonington

Jericho Bay

Maine

N

5 MILES

Paul Woodward, © 2004 The Countryman Press

VI. The Blue Hill Peninsula

SEASONAL RATINGS: SPRING ★ ★ SUMMER ★ ★ ★ FALL ★ ★ ★ WINTER ★ ★

General Description: The Blue Hill Peninsula is piece of old Maine caught between the traffic and crowds of Camden to its west and the touristy Bar Harbor to its east. The peninsula may be the most overlooked part of Maine, despite its wonderful working harbors and villages, rolling blueberry fields, and lonely wild spots.

Directions: The roads on the Blue Hill Peninsula are a bit confusing. There seems to be little rhyme or reason for the numbers given and the paths taken. In general, turn south anywhere you like off Route 1 between Bucksport and Ellsworth, and you'll be in the Blue Hill area. The village of Blue Hill is at the junction of Routes 176, 172, 15, 177, and 175. When you come to Route 15, follow it south, and eventually you will cross over to Deer Isle. Stonington is at the southern terminus of Route 15.

Specifically: Blue Hill, the largest mountain on the peninsula of the same name, rises above the town of Blue Hill and offers wonderful views of the peninsula and the surrounding waters. The mountains of Mount Desert Island are easily viewed from the summit. The peninsula juts southward from Route 1 and makes up the eastern shoreline of Penobscot Bay. Eggemoggin Reach, a long channel between the mainland and Deer Isle (connected by a bridge), defines the southwest side of the peninsula as Blue Hill Bay defines the southeast.

> **Where:** Midcoast between Penobscot Bay and Mount Desert Island
> **Noted For:** Blueberry balds and traditional harbors and villages
> **Best Time:** Mid-June
> **Exertion:** Minimal
> **Peak Times:** Spring: mid-May; summer: late June; fall: mid-October; winter: December
> **Facilities:** At developed sites
> **Parking:** In lots
> **Sleeps and Eats:** Many in every town
> **Sites Included:** Blue Hill Village, Blue Hill, Blue Hill Falls, Brooklin, Flye Point, Naskeag Point, Wooden Boat School, Reverend Daniel Merrill House, Caterpillar Hill, Brooksville, Holbrook Island Sanctuary, Castine, Deer Isle, Deer Isle Village, Stonington, Stonington Harbor, Sunset and Sunhine Roads

Blue Hill Area

Blue Hill Village (92)

The village of Blue Hill sits at the base of Blue Hill, at the southern end of the Blue Hill Peninsula, above Blue Hill Falls and at the edge of Blue Hill Bay. It is an enchanting little town, offering old buildings, churches, waterfront, trees, and mountaintop vistas to photograph. Two particularly nice buildings are the **Parson Fisher House** and **Holt House,** both constructed in the early 1800s. Just below the village along the waterfront is the **Blue Hill Town Park.** The park contains a small playground for kids, but photographers can go down to the water's edge and find

numerous compositions along the shore and across the bay. This is all within walking distance, so park your car and wander.

A nearby area for coastline photos is down Parker Point Road to **Parker Point.** To find this road, head south on Route 15 from the main center of town, and Parker Point Road is the second left. Continue down the road to just past the golf course, and park in the small dirt parking areas on the left. Some nice views of the bay and close fir-covered islands are possible here.

Blue Hill (93)

Blue Hill—the actual hill—itself offers wonderful views of the peninsula and beyond. The trek up the hill takes at least 20 to 30 minutes without lots of camera gear. Sunrises and sunsets are quite lovely up at the top, but photographers will confront a difficult task during a dark walk up or walk down the rocky and heavily rooted trail. The views are spectacular, but not wildly photogenic. You may want to do a daylight scouting trip before lugging lots of equipment up the trail.

It's always worthwhile to go for a wandering drive around the Blue Hill area. While you're getting lost, you will find lots of rolling hills, wildflowers, old buildings, blueberry barrens, trees, and rocky shorelines. Routes 15, 172, and 176 all lead in different directions from the center of Blue Hill and are worth the challenge for a few hours. These routes are photographically productive in all seasons.

Blue Hill Falls (94)

The peninsula south of Blue Hill is well worth exploring. Turn south on Route 172 out of Blue Hill, and then turn right— south—on Route 175. Shortly after the turn you'll travel over the Blue Hill Falls.

This is a reversing falls, its flow depending on the direction of the tide, and under the bridge the water churns white during changing tides. Parking is problematic; kayakers and canoeists often congregate here to practice fighting the whitewater currents. Nice views out into Blue Hill Bay are found here, as well.

Brooklin (95), Flye Point (96), and Naskeag Point (97)

About 10 miles after the falls, Route 175 reaches the small but lovely village of Brooklin. A photogenic church is located in the center of the village, with a nice cemetery across the street. If you amble around this little village, you will find all kinds of things to photograph. Don't trespass, but be sure to smile and you'll have a great time.

As Route 175 nears Brooklin, a left turn onto Flye Point Road brings photographers to a blueberry field that overlooks Blue Hill Bay. The blueberries ripen in August, and in October the leaves become scarlet, turning the field ablaze. At the end of Flye Point Road on Flye Point is the Lookout Inn from which magnificent views of the Blue Hill Bay are found.

The highlight of the Brooklin area is its beautiful shoreline. Drive down Naskeag Point Road from the center of the village to Naskeag Point for the best photography.

A boat launch area and small, rocky beach are found at the point. The boat launch side fronts a view toward Jericho Bay to the south, and the beach faces north up the Eggemoggin Reach. It is a serene area, with a combination of working and pleasure boats plying the area waters. Photographers who search for good sunset locations will appreciate this place. The hues of the setting sun reflect off the

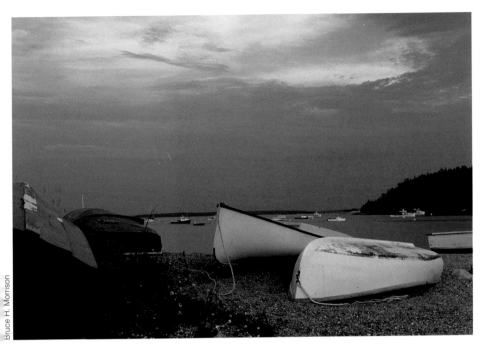

Boats, Naskeag Point

waters of the Reach and silhouette the islands out in the water. The rising sun is blocked by some islands but still provides nice pastel colors in the morning sky.

WoodenBoat School (98)

An interesting side trip off the Naskeag Point Road is a visit to the WoodenBoat School, a part of *WoodenBoat* magazine. About a mile down the road from the turnoff in Brooklin, a dirt road veers off to the right and leads to the school, which offers classes in all things maritime, including boat building, navigation, and painting. The site is open to the public and has nice vistas into the adjacent bay. A small boathouse with dock plus a secluded beach provide different views of the water and the boats in the cove.

For those of you who like to photograph churches, a quaint church is located on the Naskeag Point Road, about halfway between the turnoff to the WoodenBoat complex and the point.

Sedgwick and Brooksville

Out of Brooklin, Route 175 continues westward toward Sedgwick. Along the way a number of water views pop into sight as the road snakes through fields and woods. In Sedgwick the road reconnects with Route 172. Route 172 ends here, but a mile up the road stands the **Reverend Daniel Merrill House (99).** The house is part of a complex of beautiful 18th- and 19th-century buildings that are very appealing to photographers of historic buildings. The hours are limited, but the opportunities are great, so be sure to visit.

A few miles past Sedgwick, Route 175 intersects with Route 15. A left turn onto

Route 15 will take visitors over to Deer Isle (see below). With a right-hand turn, the two roads combine for a few miles and continue up to the top of **Caterpillar Hill (100).** At different times lots of photographic opportunities can be found at this site. The wonderful panorama rests atop a large, sloping blueberry field leading the photographic eye down toward the water. This is a marvelous spot to photograph sunsets and one that also affords both sweeping wide-angle images and close-ups of a blueberry barren.

A few miles north of Caterpillar Hill, Route 175 veers left toward Brooksville and Cape Rosier via Route 176. **Brooksville (101)** is practically surrounded by water. A drive around the area provides glimpses of rolling hills and woods and some very nice seascapes of quiet little coves. A favorite is Buck's Harbor in South Brooksville.

Past Brooksville is Cape Rosier, the peninsula's wildest spot and a lovely and lonely place with spruce moors and intimate harbors to be discovered. The best place for photographers is the 1,350-acre **Holbrook Island Sanctuary (102).** A sign on Route 176 points to Cape Rosier, and the turnoff to the sanctuary is about 1.5 miles from this junction. The sanctuary roads are unpaved and are shared with hikers and bikers. Many trails start from the road. Without combining any trails, the longest one is a 2-mile round-trip. A few are steep in spots, but most photographers can explore with their tripods and backpacks.

The sanctuary's trails traverse all the different ecosystems found here. Explorers can hike through fields and meadows onto wooded trails that lead to ponds or hilltops with scenic views of the coast, or they can seek out potential images along a shoreline path. The wetlands, coastal areas, woods (both hardwood and coniferous), meadows, and hillsides offer nesting and feeding space for a wide variety of birds and mammals. A nice mixture of wildflowers grace this natural treasure during spring and summer months, and the deciduous flora burst out each year with their autumnal hues. This area has much to offer a patient nature photographer.

Castine (103)

This unique, charming waterfront community is located on the point of land where the Bagaduce River flows into the waters of Penobscot Bay on the far western edge of the Blue Hill Peninsula. The town was settled in the early 1600s and has endured as a hamlet ever since. At various times Castine has been settled by Native Americans, French, Dutch, and English. During the Revolutionary War, British and Colonial troops engaged in a naval battle here.

Many buildings from the 1700s and 1800s still stand in Castine. In fact the village is often called "perfectly preserved" and is commonly referred to as one of New England's prettiest villages. A walking tour is the best way of capturing the flavor of Castine's history. The Castine Merchants Association publishes a map of the community, which highlights the prominent historic locations. **Dyces Head Light** still stands overlooking the bay, although it no longer functions as a working lighthouse. It is privately owned, so respect the owner's property when photographing it. Nearby is the Maine Merchant Marine Academy. The MMMA owns the State of Maine, its 498-foot

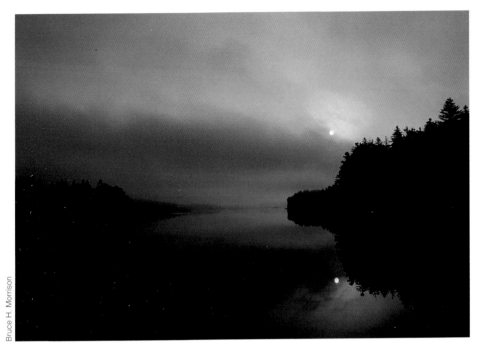

Deer Isle

training vessel docked prominently at the town waterfront. The waterfront is lovely, with public docks and picnic tables available for guests. Photographers have lots of subjects to choose from in this astonishingly beautiful village.

Deer Isle (104)

Deer Isle is the convoluted island that is across Eggemoggin Reach from the Blue Hill Peninsula. While the rest of the Blue Hill area is nice, and you will find plenty of images there, the real reason to come to the peninsula is to go to Deer Isle and its crowning jewel, the little harbor village of Stonington.

Route 15 travels more or less down the middle of the island. It is tough to tell just where the middle is because the island is so incised by water and so studded with small islands that calling anything the

middle seems a bit awkward. The bridge over the Reach is to the north, Stonington is to the south, and everything else is in between.

Regardless, the entire island is worth exploring. Travel every side road, trace every point of land—this is Maine 50 years ago. You won't find any tourist facilities here because there aren't that many tourists.

The first settlement you will come to is tiny **Deer Isle village (105),** hard stuck between Northwest Harbor and Southeast Harbor. There is not much here to photograph but there is something important for photographers. In the middle of town is the gallery of Terrell Lester, a fine-art landscape photographer who specializes in Maine coast images.

The pictures in the gallery are absolutely stunning, so much so that you

will want to come back in all the seasons pictured to try to duplicate his shots. If you can't do that, buy his magnificent book *Maine: The Seasons*. The gallery is a good place not only for inspiration but also for information. There are usually maps of the area available, and the staff is particularly helpful.

A few miles beyond the village of Deer Isle, Route 15 terminates at the magnificent fishing village of **Stonington (106).** Make no mistake about it; Stonington is my all-time favorite harbor on the East Coast. I came here 20 years ago and loved it, and neither my love affair with the village nor the landscape has much changed since then. I have called other places quintessential, but Stonington is number one on the quintessential list.

The village wraps around **Stonington Harbor (107),** a south-facing harbor that opens out on to the Deer Island Thorofare and is sheltered by Crotch Island and a number of smaller islands. Just in case you are curious, a thorofare is smaller than a reach but bigger than a passage. Anything smaller than a passage is a quick trip to the boat repair shop.

What makes Stonington Harbor so outstanding is its great harbor full of colorful lobster boats, equally colorful lobstermen, and edged by pretty little well-kept homes. It is just about impossible not to get a shot of a lobster boat without the shoreline homes behind. Of particular interest to photographers are the small rocky ledges and spits that jut out into the harbor, providing perfect foreground interest.

You can spend all day photographing in Stonington. First thing in the morning, head down to the west side of the harbor to the Greenhead Lobster Company, and shoot sunrise and early-morning light while the boats are still moored or just leaving. (This is also a good place to be in the afternoon.) In the late afternoon until sunset, I like photographing from the Isle au Haut ferry pier on the east side of the harbor. The pier sticks the farthest out into the open water, so it is easy to fill up your frame with stacked lobster boats or shoot passing windjammers running down the thorofare. Anytime of the day is worthwhile to visit the commercial fishing pier or the Public Pier in the middle of the harbor. There are near-shore ledges close by these piers, which look great on mid- to high tides.

Route 15 doesn't actually end in Stonington; it just turns back around to the north and is renamed as Route 15A. This route becomes the back way into the village of Deer Isle and passes lots of photogenic little coves and coastal scenes as it makes it way back to the middle of the island. The locals know this road as the **Sunset Road (108).**

Once back in the village of Deer Isle, if you go a very short way south again, you will come to **Sunshine Road (109)** on the left. Sunshine Road a very narrow spit of land that eventually ends in a cluster of houses known as Sunshine. There are water views the entire way along this road and lots of potential photographs to be made.

Recommendations: You should consider the Blue Hill Peninsula as a necessary sanctuary from the tourist insanity that sometimes consumes other parts of the Maine coast. Chances are that you will not come to Blue Hill on your first trip to the coast—too many other things will seduce you on the way. But when you come

back a second or third time, you will then have the strength and the wisdom to visit the Blue Hill area. Only then will you fully appreciate how special the area truly is.

The best time to go to the Blue Hill Peninsula is either in June or September and October. June is the best time for blooming gardens, both wild and cultivated, and for long, lingering sunrises and sunsets. Fall is the best time for fog and colorful forests and blueberry barrens. If you come here in October, you will be the only non-native because the rest of the tourists are all stuck in traffic between Ellsworth and Bar Harbor.

Pro Tips: When you are photographing the harbor at Stonington, beware of the huge cranes that are often visible across the water on Crotch Island. The cranes are part of a quarrying operation, and they have ruined many a harbor-skyline shot.

The lobster boats leave first thing in the morning, so by midmorning most will be gone from the harbor. They begin to reappear in midafternoon, and by the pretty light of late afternoon, all the boats have returned. While there are many places to photograph the harbor, some places are private and not happy to see photographers. Always ask if you want to go on to someone's property. Chances are you will be welcomed.

In the summer, particularly in the middle of the day, there is often a white, hazy rim of clouds around the horizon with blue sky above. Many people think that with the proper filter they can make the white rim bluer and more tolerable photographically. These people would all be wrong. Anything that makes the white clouds better will make the rest of the scene worse. Just don't include the hori-

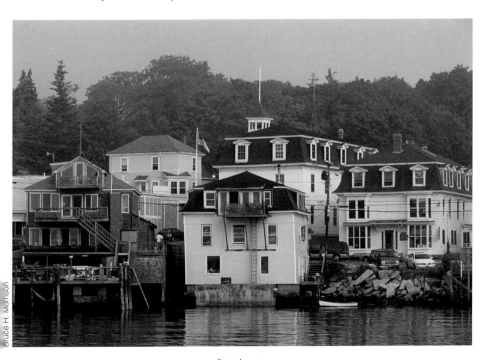

Stonington

Life jackets, Brooklin

zon at midday in any of your compositions. Besides, what are you doing shooting at midday?

Cautions: All the roads on the Blue Hill Peninsula are narrow and twisty, so parking or even just pulling over are always difficult and sometimes dangerous. It's best to find a better spot and walk back to where you want to photograph than risk getting into an accident just for a picture.

If you travel for more than 30 minutes on the peninsula, you are going to get lost. The roads take erratic turns, and they are numbered in a seemingly random fashion. Now, getting lost is often quite productive if you have lots of time and have your camera close by. Photographers never actually get lost—they just find alternative shooting locations.

If you would rather get to where you want to go directly (well, sort of directly), you'll have to break down and get a map. Don't bother with a map of the entire state; get a map of just the Blue Hill area, or get a DeLorme Gazetteer for the necessary details.

Diversions: The **Haystack Mountain School of Crafts** is a nationally known school for artisans and students working in clay, wood graphics, fibers, metals, and glass. The two- to three-week classes happen all summer long, though visitors are always welcome. The studios are only open at certain times, but there are often evening lectures and presentations in the school's auditorium. The view from the campus out over Jericho Bay is also outstanding. It is a killer place for sunrises.

VII. Mount Desert Island and Acadia National Park

SEASONAL RATINGS: SPRING ★ ★ ★ SUMMER ★ ★ ★ ★ FALL ★ ★ ★ ★ WINTER ★ ★ ★

General Description: There are two halves of Mount Desert (pronounced *da-'zart*) Island. Most people go to the eastern side for Bar Harbor, Cadillac Mountain, and the Park Loop Road that gives access to the coast. This lobe is consequently the most crowded. The western lobe has less national parkland but is just as pretty. If the crowds are nuts around Bar Harbor, head to the western side of the island.

Acadia National Park is *the* photographer's playground on the East Coast; there are wonderful things for all photographers here. The tallest mountains on the East Coast are here plus its only true fjord. There are also stunning rocky coastlines, beautiful harbors, pretty lakes and ponds, a great lighthouse, and wonderful carriage roads.

Directions: Mount Desert Island is about 20 minutes south of Ellsworth and about an hour and a half south of Bangor (the closest large airport). Route 3 leads from Ellsworth, across the bridge to the island, and then directly to Bar Harbor, the largest town and the commercial center of the island. Route 3 loops around the eastern lobe of the island, and Route 102 loops around the western lobe of the island.

Specifically: Acadia National Park covers about half of Mount Desert Island but the entire island is wonderful. There is a reason this is a national park: The scenery is spectacular. Cadillac Mountain is the

Where: The largest island on the coast, due south of Ellsworth

Noted For: All things wonderful: harbors, lighthouses, mountains, lakes, and coastline

Best Time: Mid-October

Exertion: Minimal to moderate hiking

Peak Times: Spring: mid-May; summer: early July; fall: mid-October; winter: January

Facilities: At developed sites

Parking: Easy, in lots

Sleeps and Eats: Mostly in Bar Harbor but also in other area towns

Sites Included: *The Towns*: Bar Harbor, Boat Trips, Bar Island, Bar Harbor Shore Path, Somesville, Southwest Harbor, Northeast Harbor, Thuya Garden and Asticou Terraces, Asticou Azalea Garden, Bass Harbor, Bernard. *The Coast*: Sand Beach, Great Head, Thunder Hole, Otter Point, Otter Cliffs, Boulder Beach, Seawall Beach, Big Heath, Wonderland Trail, Ship Harbor Trail and Ship Harbor, Bass Harbor Head Light, Indian Point Blagden Preserve. *The Lakes*: Jordan Pond, Cobblestone Bridge, Bubble Pond, Eagle Lake. *The Mountains*: Cadillac Mountain, The Bubbles, The Beehive, The Bowl, Penobscot Mountain, Sargent Mountain. *The Rest*: Eagle Lake (Duck Brook) Road, Wild Gardens of Acadia, Birch Forest

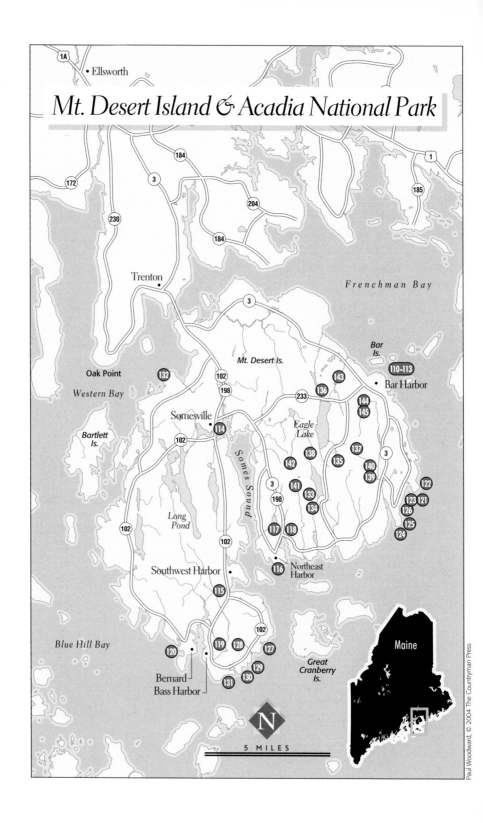

Mt. Desert Island & Acadia National Park

• Ellsworth

1A

172

230

184

3

204

184

Trenton

Frenchman Bay

3

Bar
Is.

110-113

Oak Point

132

102

Mt. Desert Is.

143

198

233

136

Bar Harbor

Western Bay

144

145

Somesville

114

Eagle
Lake

137

3

Bartlett
Is.

102

138

135

Somes Sound

142

140

139

3

198

141

133

122

Long
Pond

134

123 121
126

102

117

118

125

124

102

116

Northeast
Harbor

Southwest Harbor

115

102

Blue Hill Bay

120

119

128

127

Great
Cranberry
Is.

129

Bernard
Bass Harbor

131

130

Maine

N

5 MILES

Paul Woodward, © 2004 The Countryman Press

tallest on the island, and a road goes all the way to the top, making it a superb spot for both sunrise and sunset photography. There are also miles and miles of hiking trails and carriage roads for further exploration.

The Towns

Mount Desert Island is an intriguing combination of wild beauty, old money, and hard-working families. Each town and hamlet scattered across the island has its own unique flavor, based on their mixture of these ingredients.

Bar Harbor (110)

Bar Harbor is the commercial center of the island and the spot where most tourists start and finish their visit to the island. In town there is not much for the photographer except a few nice restaurants, a natural history museum, an oceanarium (just north of town), bookstores, galleries, shops, and bakeries. There might be an ice cream shop or two as well. July through September is the busiest time of the year.

Bar Harbor once was a town of splendor, with huge waterside mansions ringing the shore. Some of these old homes are still around, but they are either privately owned or difficult to see. There still is splendor in the harbor, where **windjammers** that once brought the well-healed up from Boston and Portland now take tourists out for day and overnight trips. Not only are the views on these trips great, but the picture possibilities aboard the boat of the vessel and sails are also very nice.

Other **boat trips (111)** of various kinds are possible, as well, out of Bar Harbor. Several companies offer whale-watching cruises, there are sunset cruises, lighthouse cruises, and wildlife cruises. On every boat trip you take, you are likely to see the resident bald eagles that nest nearby. I have heard that some of the trips even feed the eagles as they motor by the nests. While ethically questionable, it does allow close views of the birds.

Two easy walks can be taken from town. The classic one is to walk the 0.5 mile across the harbor to **Bar Island (112).** Unless you have some very good connections, it's best to do this an hour on either side of low tide. Of course, you are going to stay out there either for a couple of hours or for twelve hours, when low tide returns. It's best to wear a watch and keep your wits about you. Photographically, the most interesting stuff is on the walk out in the tidelands. The close side of the island is private, so be respectful.

The other walk has a bit less adventure but is just as pretty. The **Bar Harbor Shore Path (113)** is a .75 mile long shoreside walk that provides great views of the harbor, the offshore islands, and some beautiful old mansions. The path starts on the east side of the town wharf.

Directions: Bar Harbor is on Route 3. You can't help but go through it; it's magnetic for all tourists.

Somesville (114)

Somesville is a small village at the head of Somes Sound. You would most likely drive right by and not notice Somesville except for two things. First, Somesville is a National Historic District, so it will definitely show up on your pretty radar and is worth exploring. Second, and the thing that will actually get you to stop, there is a

beautiful little **arched white bridge** right by the road that is a photograph dying to be made. The bridge is part of the Somesville Museum, which is also worth a visit.

Directions: Somesville is at the northern end of Somes Sound at the junction of Routes 198 and 102. There are two villages on Somes Sound, and while they're superficially similar, they are actually quite different:

Southwest Harbor (115)

Southwest Harbor is the working side of the sound, with lobster boats in the harbor and modest homes lining the streets. There are nice views here to the east across to Greening Island and the impressive homes of Northeast Harbor. The best views in Southwest Harbor are from the front lawn of the Claremont Hotel. Some say it is one of the best views of the water on all of the islands.

Northeast Harbor (116)

Northeast Harbor is the upscale side of the sound, with large waterfront homes (especially along Gilpatrick Drive) and large, mouthwatering yachts. Besides the elegance of the town, there are other things to photograph here. **Thuya Garden and Asticou Terraces (117)** are public formal gardens at the head of little Northeast Harbor, just north of town, and if you like gardens these two are very impressive. Even if you don't want to photograph the gardens, they are a great place to while away a few hours of dreadful light. **Asticou Azalea Garden (118)**, the

Southwest Harbor

Fall generates a color theme

third garden in the area, is Japanese inspired and planted—as the name implies—mostly with different varieties of azaleas and rhododendrons. In late May through June, the gardens are ablaze with stunning blooms of vibrant colors. Come on a cloudy or lightly raining day for your best opportunities.

Directions: Asticou Terraces and Thuya Gardens are .05 mile south of the junction of Routes 198 and 3. Asticou Azalea Gardens are just north of this intersection. Northeast Harbor is just south of this intersection.

Bass Harbor (119) and Bernard (120)

Both of these villages are on Bass Harbor, the most traditional harbor on Mount Desert Island. I know it's a bit confusing, but it is such a small and pretty area, it really isn't that important where you are. The village of Bass Harbor is on the east side, so it's the sunset village, and Bernard is on the west side, making it the sunrise village. But don't just photograph them at those times. Lobster boats, piles of ropes, fishing shacks, reflections and the like await to be photographed here at all times during the day. Even the little inlet channel is photogenic at mid- to low tide.

Directions: Bass Harbor is on the far southern tip of Mount Desert Island. Take Route 102 from Somesville until you see signs for Bass Harbor and the Bass Harbor Lighthouse on Route 102A. A mile or so beyond Route 102A is the turn to Bernard on Bernard Road.

The Coast

To many photographers the coast of Mount Desert Island is the main attrac-

Along Ocean Drive, Acadia National Park

tion. Renowned for its pounding surf against huge slanted rocks, it can also be calm and reflective against a dark-green backdrop of spruce trees and seaweed-covered shores. And the coast changes all the time. It will be different in the morning than it is in the afternoon, different at low tide than it is at high tide, different in fog than it is in sunshine, different in summer than it is in fall.

The first five sites are on Park Loop, a one-way road that circumnavigates Cadillac Mountain on the eastern lobe of Mount Desert Island. You can stop anywhere on this road and find things to photograph. These spots are my favorites.

Sand Beach (121) is the last best beach in Maine, heading down east. The beach—by most beach standards—is small, and the sand is a bit coarse, but the waves are strong, so if you want a break from the monotony of beautiful mountains and forests, it's a good spot to photograph something different. Behind the beach and over the dunes is a small salt marsh that can be pretty, especially in fall and winter. Look for wildflowers in the dune grass or growing around the driftwood in summer. The beach looks due south and is tucked between two highlands, so there isn't much early or late-day photography on the beach.

There is a nice walk you can do around **Great Head (122),** the high knob on the far side of the beach, which takes you out to expansive views of Frenchman Bay and the ocean. The trail starts at the far side of Sand Beach and circles Great Head in a 1.8-mile loop. Much of the trail is open, so there are great views back over the beach and out to the islands in Frenchman Bay and to Schoodic Peninsula.

Immediately past the turn to Sand Beach, the Loop Road closely follows the coast. This is the best part of the park to photograph classic rocky coastal scenes and dramatic seascapes. **Thunder Hole (123)** is midway along this section and is wellknown for the thundering sound and water spout made when waves crash into a narrow waterside cave. The best time to be here is in the morning, when the light is nice and the crowds are smallest.

Past Thunder Hole are **Otter Point (124)** and **Otter Cliffs (125)**. The road traces the top of the cliffs, with ample parking to allow for easy exploration of the area. The cliffs are on the eastern side of the point, so the best light will be in the morning. From Otter Point you look south, so you can shoot it in the morning or the afternoon. At low tide there are good tide pools here, as well.

The famous but hard-to-find view of Otter Cliffs is before you get to the Otter Point parking lot. Between Thunder Hole and Otter Point is a trailhead parking area for the Gorham Mountain Trail. Park there, and walk south down the Loop Road to the intersection of Otter Cliff Road on your right. Opposite this intersection is a short informal trail that leads through the thin forest to the ocean.

At the end of the trail, opposite the intersection, is a small **boulder beach (126)** (known as "boulder beach") that makes a magnificent foreground for pictures of Otter Cliffs. The beach rocks are all beautifully and intriguingly rounded and vary in size between baseball and beachball, so you can choose to photograph wherever the size suits your foreground fancy. Photos of just the rocks can also be compelling, especially if you find wildflowers or driftwood among them. Photography

here is best right at sunrise and in the early morning. In the afternoon Otter Cliffs are shaded. The beach is also a good winter photography site when there is snow on the rocks.

On the southern tip of the western lobe of the island are three great places to catch a photograph. **Seawall Beach (127)** is a rocky beach with crashing waves and tide pools at low tide. The beach looks southeast, so it's a good spot for photographing sunrise or late-afternoon seascapes. Incidentally, that's **Great Cranberry Island** offshore (accessible by ferry from both Southwest and Northeast Harbors), a good backdrop for the rising sun.

Past Seawall the road dips inland, skirting the fringe of **Big Heath (128),** an enormous bog without any formal trails but with lots of exotic wildflowers like pitcher plants, sundews, and gorgeous bog orchids to photograph. The catch is that when the wildflowers are blooming, the mosquitoes and black flies are biting. You will never see bigger insects or bigger bites than those from Big Heath.

There are a few informal paths that lead into Big Heath but they don't go very far. It's best to stay on these trails because the plant life is very fragile and the impact of one footstep can last for many years. You can explore the edge of Big Heath by walking the Hio Road. This is an old fire road that's closed to cars and little known to tourists. Find the start of this road at the back of the Seawall Campground on Loop C.

On the ocean side of Big Heath are two trails that lead through very pretty forests to the wild edge of the sea. You will find moss-covered ground and gnarled trees, lichen-covered ledges with twisted pitch pines, lush meadows fringed with flower-

ing shrubs, and tall spruces at waters edge. The .07-mile long **Wonderland (129)** is the less popular and one of my favorite trails in the park. In its short length there is a surprising amount of diversity, which translates into lots of stuff to photograph. Next to Wonderland you'll find **Ship Harbor Trail and Ship Harbor (130).** The trail (1.3 miles long) gives you access to the intimate little harbor and takes you through equally beautiful forests. In early June the shrubby rhodora (a wild rhododendron) blooms along both Wonderland and Ship Harbor trails and is a magnificent flower to see. Wildflowers are good here from mid-May to late July.

This is the wildest part of the island—at least it feels that way to me—and gives you a different set of plants, patterns, and textures to photograph than you will find in the rest of the park. In combination with Big Heath, you will also find different animals here, most prominently birds. Because the trees are fairly short, this area is well known to bird photographers as a place to get singing treetop birds without building a tower and a blind.

After you come screaming from the forest on your early-summer visit and realize that Wonderland is so named because it makes you wonder how there can be so many mosquitoes in one small area, head to the more civilized **Bass Harbor Head Light (131),** just down the road. This is one of the most published lighthouses in Maine because of its classic lighthouse setting and its ability to be photographed well at both sunrise and sunset.

The lighthouse perches on top of seaside cliffs in a dense forest, so your choice is to photograph it from the rocks below on the east side or on the west side. A trail leads to the east side, making it the easiest

and probably the best place to photograph the light. You will have to walk as far down on to the rocks as is feasible and safe to get the best pictures. Shoot it at sunrise, with that great warm light, or against the sunset sky.

Directions: Seawall, Big Heath, Wonderland, Ship Harbor, and the Bass Harbor Head Light are all on Route 102A, a loop that comes off Route 102 just south of Southwest Harbor. All locations are well signed.

Indian Point Blagden Preserve (132)

If solitude is as important as a beautiful landscape, go to the Indian Point Blagden Preserve on the north side of the island. This is a secret spot that no one knows about, so you won't find any of the "Great Unwashed" here—unless, of course, *you* haven't bathed in a while. This 110-acre forested Nature Conservancy sanctuary includes a long stretch of shoreline, so you'll be able to photograph virtually all the areas of the park from right here. Offshore is a good spot to look for seals.

Tom Blagden Jr., part of the generous family that donated this land and a dedicated conservationist, is also a magnificent nature photographer. He has done what I think is the best photography book on Acadia National Park, titled *First Light: Acadia National Park and Maine's Mount Desert Island.* The book is not only jaw-droppingly beautiful but also inspiring to all photographers who visit the island. Purchasing the book supports island conservation projects, so buy a copy, grab a glass of wine and a comfortable chair, and linger over the photos.

Directions: From Somesville take Oak Hill Road on the north side of town west

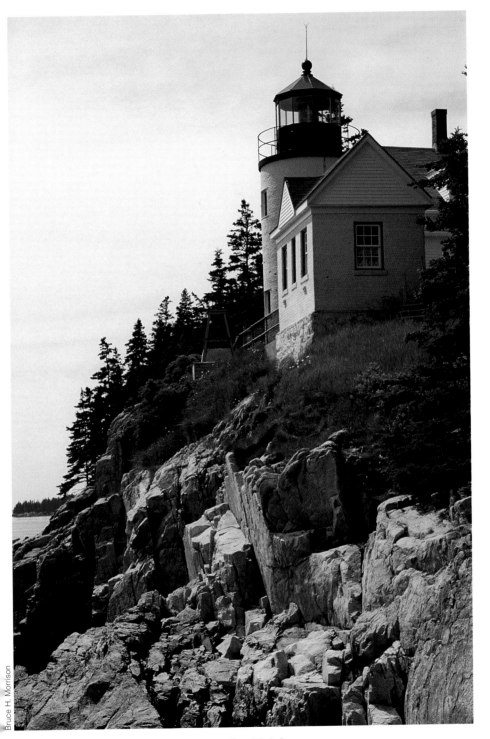

Bass Harbor Lighthouse

and then north to the crossroads of Indian Point. Turn left onto Indian Point Road and then quickly right at the Y onto an unmarked road. Follow this road to the parking area.

The Lakes

There are lots of lakes, ponds, tarns, and pools on Mount Desert Island. The three that are best known to photographers are Jordan Pond, Bubble Pond, and Eagle Lake.

Jordan Pond (133)

Jordan Pond nestles between Pemetic and Penobscot Mountains in the middle of the eastern lobe of the island. A trail circles the pond at water's edge, so it is easy to photograph both the forest and the water at any time of the day. Look for woodland wildflowers in early summer and colorful reflections in fall. The classic shot is down the lake with the Bubbles (those rounded knobs at the head of the lake) in the background.

The trail around the lake is a bit over 3 miles long and can take anywhere between two to four hours to walk and photograph. Look for rocks and reeds at the shore's edge for foreground and boulders in the forest for some points of interest in your forest compositions. There is also a 1-mile nature trail that's worth exploring. Jordan Pond is also a good spot to explore by canoe.

About 1 mile south of the Jordan Pond House is a very photogenic **cobblestone bridge (134)** on the carriage road that follows Jordan Stream, the outlet of Jordan Pond. This is one of the prettiest bridges you will ever see, with its granite block arch and cobblestone facing. It's also one of the prettiest settings you will ever find for a bridge, being tucked into the hardwood forest along Jordan Stream. Go upstream and photograph the bridge in its surroundings, with the stream and forest for a terrific shot.

Because of its location, Jordan Pond is often foggy in summer and foggy and frosty in fall, so it's a good place to check out first thing in the morning. The Jordan Pond House, at the south end of the lake near the parking area, is a good place for midmorning snacks and is known for its popovers and afternoon tea.

Directions: Jordan Pond is on the Park Loop Road a few miles south of Seal Harbor and a few miles north of Bubble Pond. Access is on its south end.

Bubble Pond (135)

On the other side of Pemetic Mountain from Jordan Pond is a narrow little pond—Bubble Pond—that has a carriage road along its western edge. There's a nice stone carriage path bridge at the parking lot and a pretty outlet stream across the road from the parking area. If you follow the stream, you'll find lots of pretty scenes to photograph, and you'll shortly arrive at the south end of Eagle Lake. Several little islands off the shore here make nice elements in a composition.

Directions: Bubble Pond is on the Park Loop Road a few miles south of Jordan Pond and a few miles north of the road up Cadillac Mountain. Access is on its north end.

Eagle Lake (136)

This is one of the bigger lakes on the island and one of my favorites. A combination of carriage paths and trails circum-

navigates Eagle Lake in a 6-mile route, so you can get all the access and solitude you want here. I never get much beyond the lakeshore close to the parking lot because between the views of Cadillac Mountain to the east, the nice forest of beeches and birches, and the reflections wherever you look, it's hard to make much progress on the paths and trails. The arched stone carriage path bridge at the parking lot is often photographed—and deservedly so.

Directions: Eagle Lake is on Route 233 a few miles west of Bar Harbor. Access is on its north end.

The Mountains

Mount Desert Island is the most mountainous section of the Maine coast. It is, in fact, the most mountainous part of the Atlantic Coast all the way down to Brazil.

All the major mountains have a trail or three, a carriage path, or a road going to the top. And many of them have rocky summits, so the views are outstanding.

Cadillac Mountain (137)

Cadillac Mountain is the tallest mountain on the island and with a good, paved road all the way to the top, it's a mecca for photographers. It is often written that the summit of Cadillac Mountain is the first place the sun strikes in the United States. Whether true or not, it's the first place where the sun strikes photographers in America because there are always photographers on top trying to capture the sunrise.

The view east or west is interesting, with the islands in Frenchman Bay adding interest to the foreground looking east and the lakes and Somes Sound

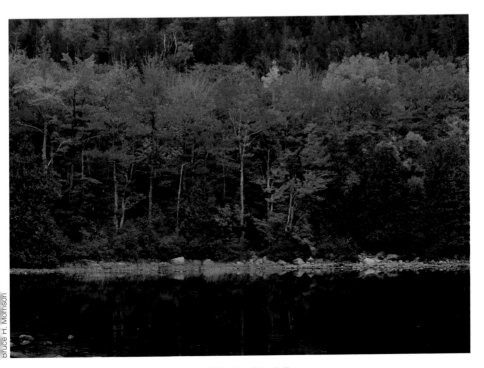

Bruce H. Morrison

Bubble Pond in fall

View from the top of Cadillac Mountain

adding interest looking west. The hours after sunrise and before sunset are also very pretty on the summit. Look for wind-twisted trees for more foreground interest or cracks as leading lines for your grand summit landscapes.

Most of the top of the mountain is open rocky slopes, so you have the freedom to wander wherever you wish. It's often windy on top, but it isn't hard to find compositions on the leeward side of the summit. It's also much colder on top than it is down below, so always bring lots of layers. In the fall it isn't uncommon for it to be below freezing on top, factoring in the wind chill.

Directions: The road up Cadillac Mountain is on the Park Loop Road about 10 minutes from Bar Harbor.

The Bubbles (138)

These are the knobby ridges of two rounded summits that lead between Jordan Pond and Eagle Lake. They're the two little mountains that are so obvious at the north end of Jordan Pond. While it's an interesting walk along the Bubbles, what attracts most attention is the very obvious Bubble Rock, a large erratic (a glacially deposited boulder) perched in the open on the ridge of South Bubble.

It's a pretty easy walk up to the erratic, and it becomes more and more impressive as you get closer to it. The boulder makes for a good subject and a great bit of foreground for sweeping landscape shots. There are very nice views of both Jordan Pond and Eagle Lake from anywhere on North or South Bubble.

Directions: The trailhead parking lot for the Bubbles is a couple of miles south of the Bubble Pond parking area on the Park Loop Road. The turn is well signed. It's about half a mile to Bubble Rock via the South Bubble summit.

The Beehive (139) and The Bowl (140)

These are two well-known hiking destinations that, in a short distance, provide photographers a little bit of everything in the park. The Beehive is a beehive-shaped rocky knob with prominent cliffs on its south side. The Bowl is a small pond hidden between the creases of Champlain Mountain.

If you like thrills, take the Beehive Trail that goes to the top via iron ladders drilled into the cliff face. This is not a route for the faint of heart nor for photographers with a full and heavy camera bag, but it is fun, and it makes for some great travel shots of people climbing the cliffs. From the top of the Beehive there are good views over Sand Beach and Great Head across to Frenchman Bay.

If this thrill is not your can of film, you can take a trail around the Beehive and go to the Bowl by a much easier route. The Bowl is a beautiful little glacial tarn, often protected from the wind, so reflections of the forested shore can be very pretty. There are also interesting views of Champlain Mountain looming overhead.

Directions: The trail to the Beehive and the Bowl starts across the road from the Sand Beech parking lot. It's about a 1-mile round-trip to walk to the Bowl, a little longer if you go over the Beehive.

Penobscot Mountain (141) and Sargent Mountain (142)

Two of the highest mountains in the park, Penobscot and Sargent sit just east of Jordan Pond. Together they are known

for their long subalpine open ridges and wonderful views from their summits. These are not the most accessible mountains in the park, but they are some of the most profitable photographically because you will get pictures that no one else has, and you will see a part of the park that few people ever see. Peregrine falcons nest on the cliffs of Penobscot Mountain.

This is a strenuous 5.2-mile hike, so don't bring all your gear. You'll need a wide-angle lens for landscapes because there are magnificent views of Jordan Pond, Eagle Lake, and Somes Sound. Take a short telephoto, as well, so you can zoom in on details of the mountainous landscape. And don't forget a lens that will allow you to capture the small, beautiful details of the forest and subalpine zone, such as wildflowers and lichen patterns. Take this hike on a hot summer day to avoid the bugs and heat of the lowlands.

Directions: The trail starts at the Jordan Pond parking lot. Follow the signs to the Penobscot Mountain Trail, the first mountain you will climb, and then follow the Sargent Mountain Trail, the second mountain you will climb. You can return to the car via the Jordan Cliffs Trail or via a nice and easy carriage path once you've descended off Sargent Mountain.

The Rest

As you might expect, there are other things to photograph here than just the coast, the lakes, and the mountains. Everyone who has been to Mount Desert Island has their own personal favorite and secret places. I am only going to share with you my favorites if you promise to go out and find your own (and tell me later). Here are my favorite and no-longer-secret places.

Eagle Lake Road (143)

This is one of the best places to avoid the tourist crowds, especially in the fall. Also called Duck Brook Road, this gravel road connects the north end of Eagle Lake with the west side of Bar Harbor on West Street. It passes through a low, sort of boggy, sort of barren kind of landscape that is thick with beautiful lichens, intimate pools, and gnarled trees, stunted by living on exposed bedrock.

In the fall this road is great because there are lots of blueberry bushes that turn bright red, highlighted against the green needles of the stunted pines. I have also had great success photographing colorful leaves in slow-moving **Duck Brook.** Park your car where you can, and start walking. You won't be disappointed.

Directions: The easiest way to find this road is to drive eas\t from the Eagle Lake parking lot, and then turn north (left) on to Eagle Lake Road. The road follows Duck Brook, the outlet of Eagle Lake, so just look for the brook, and you'll find the road.

Wild Gardens of Acadia (144)

This is a wonderful garden featuring the plants native to Mount Desert Island. If you don't want to hunt all over for the pretty plants, you can find most of them right here, with neat labels and comfortable benches nearby. Also in this area is the **Abbe Museum,** dedicated to preserving New England's Native American heritage, and the **Park Nature Center,** which is mostly geared toward children.

The secret part of this location is what's in back of the gardens. Follow any one of the trails leading into the surrounding forest, and you'll walk into a

spectacular **birch forest (145)** carpeted with dense ferns. The Jessup Trail leads through this forest as it heads to the Tarn, a small lake next to the park entrance station. If you get here when it's lightly raining or foggy, you might just never leave.

Directions: The gardens and the birch forest are located at the Abbe Museum and next to the Sieur de Monts Spring, both of which are near the park entrance station. Access is either off the Park Loop Road or off Route 3 as it heads south out of Bar Harbor. Look for signs to the museum or the spring, and you will find the gardens and the birch forest.

Recommendations: As with the rest of the Maine coast, my favorite time to photograph is when it is foggy. You can go anywhere and find wonderful things to shoot. The coast is also great on sunny days, but try to avoid midday and the harshest light. Take a boat trip at midday, or go for a hike and wash the tourists out of your system.

You can go anywhere in the fall, as well, and find pictures. You will also find lots of people and photographers, but that's the price you have to pay for photographing in paradise. In spring I would stay in the valleys and hunt for wildflowers or head to the harbors and catch their preparations for summer. In July, August, and October, take a hike or a walk, and you'll leave most of the tourists behind you. This is also a good time to explore some of the near islands like **Isle au Haut** or **Great Cranberry Island.**

Pro Tips: If you are planning to photograph sunrise on top of Cadillac Mountain, figure on arriving at least 30 minutes before sunrise to find a spot and capture the early glow of presunrise. Stick around after you get your rising sun shot because I think some of the nicest light on the mountain is the hour or two after sun-

View from Cadillac Mountain at sunset

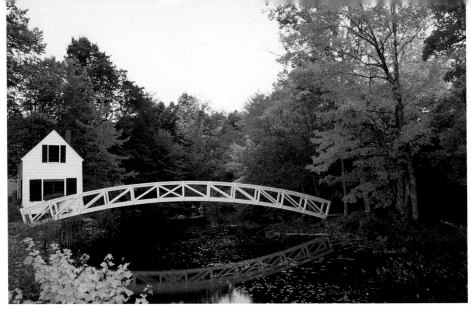

Arched bridge, Somesville

rise—and the hour or two before sunset. Bring lots of layers and a windbreaker to keep yourself warm while you wait.

Grab some postcards when you're in Bar Harbor, and take them with you to get in the general location of each shot. You'll never be able to duplicate the image on the postcard, but it will give you a good place to start to look for compositions.

Salt spray can be hard on camera gear. If it's windy or the waves are pounding the coast and you are near, use a skylight filter to protect your lens from the salt. I usually keep a damp towel in my car to periodically wipe off the camera body, as well. At the end of the day be sure to give your tripod a bath or else it will seize up and be useless to you.

For all of you who are planning a trip to Acadia to catch the peak of fall color, be aware that the peak along the coast is about a week later than it is inland. In most of New England the peak color is somewhere between the 10th to the 14th of October, give or take a week. In Acadia the peak is closer to the 14th to the 18th, and I have known it to be as late as the 22nd of October. If there isn't enough color where you are, either go higher in elevation, or drive off the island and go north until you find better color.

Cautions: The most dangerous things on the island are distracted drivers. Some of the roads are narrow, and some people do drive too fast, so just slow down and pull over, and let the crazies zoom past as they miss most of the park. You should also be careful on the rocks along the coast. It is very easy to twist an ankle or bang a knee if you're paying more attention to finding your next shot than finding your next step. If rocks look wet, they probably are—and that means they are certainly slippery. Seaweed is slippery, too.

Remember, not all of Mount Desert Island is national park property. Real people actually live there doing real-people things. Chances are they don't want to look out their windows and see you

tromping around their yard or investigating their stuff. If you are moved to get closer, then ask first and shoot later.

Diversions: In case you have nothing to do while in Southwest Harbor, two places are worth checking out. The first is the **Wendell Gilley Museum,** which displays the works of this master bird carver. The birds are astonishingly beautiful, so take some time and enjoy these works of art. The second is the **Hinckley Boatyard,** makers of the prettiest sailboats I have ever seen. These are more than just sailboats, though. These, too, are works of art—as their prices prove. But even if you are not in the mood to buy one (or buy one for me!), it's a nice place to wander and gawk at the boats. There is also an **Oceanarium** in Somesville on Clark Point Road that has lots to see, especially for children.

Just about anywhere you go on the island, galleries beg for your attention. Some show watercolors and oils, some show pottery, and some show everything in between. I like going into galleries because not only do I enjoy seeing the art, but the locals are great sources of information as to where the prettiest places are. Nothing better than asking a local artist where they go to get inspired.

Of course, you could always go for a walk or a hike. There are well over 100 miles of trails, bridal paths, and carriage roads on Mount Desert Island, and all will show you wonderful places. A worthwhile pursuit would be to find every carriage road stone bridge on the island. There are 17, and each one is different, and each is photogenic. Get the book *Acadia's Carriage Roads* by Robert Thayer if you are interested in the carriage roads or their bridges.

Nearby: The Blue Hill Peninsula to the east of Mount Desert Island is a reasonable day trip if you want to get off the island for a while. See Chapter 6 for more details on this rural area. Going farther east—or going Down East, as the locals say—will quickly get you to the mostly forgotten part of the coast where tourists seldom go and the locals like it that way. See Chapter 9 for more details on the Down East coast. Isle au Haut is well west of Mount Desert Island, but it is part of Acadia National Park. See Chapter 8 for more details about this wild island.

David Middleton

Rope coils

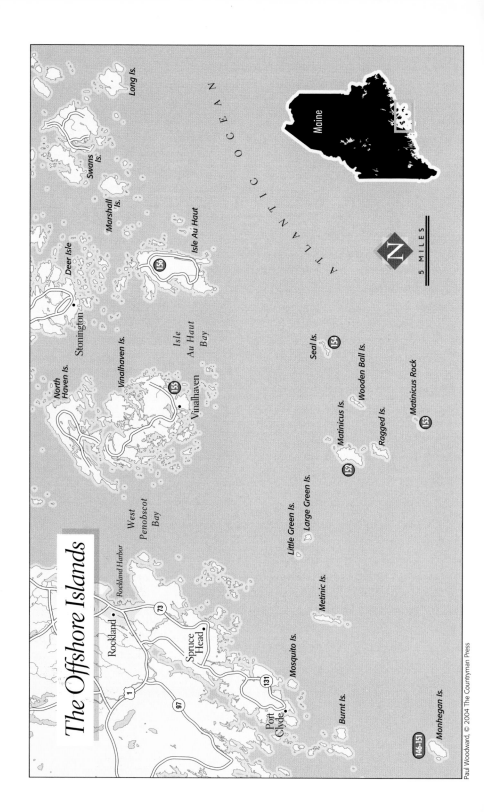

The Offshore Islands

Maine

N

5 MILES

Long Is.

Swans Is.

Marshall Is.

Deer Isle

Isle Au Haut

Stonington

156

North Haven Is.

Vinalhaven Is.

Isle Au Haut Bay

155

Vinalhaven

Seal Is.

154

Wooden Ball Is.

Matinicus Is.

Ragged Is.

Matinicus Rock

153

152

West Penobscot Bay

Rockland Harbor

Little Green Is.

Large Green Is.

Rockland

73

Spruce Head

Metinic Is.

1

131

Mosquito Is.

97

Port Clyde

Burnt Is.

146-151

Monhegan Is.

ATLANTIC OCEAN

Paul Woodward, © 2004 The Countryman Press

VIII. The Offshore Islands

SEASONAL RATINGS: SPRING ★ SUMMER ★ ★ ★ FALL ★ ★ ★ ★ WINTER ★ ★

General Description: If you like off-the-beaten-path destinations that are windswept and weatherworn, dotted with buildings and people that are equally windswept and weather worn, these five islands are the places for you.

Directions: All the islands are accessed by ferries that run more or less regularly, depending on the season and the whims of the weather. Ferries to Monhegan leave from Boothbay Harbor, New Harbor, and Port Clyde (Port Clyde is the closest). The ferry to Matinicus leaves from Rockland, as does the ferry to Vinalhaven. Isle au Haut is reached by a ferry from Stonington. Machias Seal Island is reached by reserving with a private tour boat operator.

Specifically: While not the easiest places to photograph, the rewards of perseverance are truly great. Island harbors and homes are working harbors and homes; nothing is for show on these islands. Consequently, there is an authenticity to photographs taken here that's difficult to find elsewhere along the coast. In addition, you'll find high seaside cliffs and protected coves with pocket meadows, rocky shores, and abundant compositions waiting to be harvested.

The Islands

Maine's offshore islands are more than little pieces of the mainland adrift at sea. They are different than the Route 1 coast; they look different, they feel different, and the people who live there are different. These six islands are what the Maine coast

> **Where:** Ferry-accessible islands from mid-coast to Downeast
> **Noted For:** All things weather-beaten: harbors, lighthouses, buildings, and coast
> **Best Time:** Mid-October
> **Exertion:** Easy to moderate walking
> **Peak Times:** Spring: mid-May; summer: early July; fall: mid-October; winter: January
> **Facilities:** Only in island villages
> **Parking:** Cars either not allowed for visitors or strongly discouraged
> **Sleeps and Eats:** In island villages
> **Sites Included:** Monhegan Island Light, Monhegan village, Monhegan lighthouse, South Loop Trail, North Loop Trail, White Head Trail, Matinicus Island, Matinicus Rock, Seal Island, Vinalhaven Island, Isle au Haut

was like a century ago—life shaped and controlled by the sea, wind-sculpted and weather-beaten. You won't find convenience stores here or coffee shops because nothing is convenient.

Monhegan Island (146)

Monhegan is the best known of the offshore islands, with a history that some say precedes the Pilgrims and an artistic tradition that goes back more than 150 years. Once you get there, you will see why; everything on Monhegan, from spruce to shack, looks as if it has been perfectly placed, perfectly weathered, and is part of a perfect scene. OK, it's not *quite* like that, but most of it is pretty darn wonderful.

Monhegan Island, 10 miles from the

mainland, is 1.75 miles long and .05 mile wide, so at about 1 square mile it is not a big island—which is fortunate because everywhere you go, you have to go on foot. The harbor is on the west side of the island, tucked into the narrow channel between little Manana Island and Monhegan.

The topography of the island is like a tilted whale's back: highest in the middle, cliffs seaward, and low toward the mainland. The west side is the lowest and most protected and is mostly cobbly coves and low rocky ledges. The east side is cliffy and the most exposed to the sea. Three high points mark these cliffs: Burnt Head to the south, White Head in the middle, and Black Head to the north.

The **village (147)** is just uphill from the ferry dock and dominated by the huge Island Inn. At almost 100 years old, the inn has become a lasting icon of the island. Behind the inn on the highest point on the island is the **Monhegan Island Light (148).** The lighthouse is closed to visitors, but there are magnificent views over the village and harbor from its lawn. The cinderblock lighthouse itself is not photogenic, but the buildings are nice, and usually a picturesque old fishing dory is nearby.

There are about 100 residents in the winter and 600 or so in the summer, but that doesn't include the boatloads of people who arrive and mostly depart every day. All the houses and fishing shacks are either concentrated around the harbor or on the west side of the island, putting

Village of Monhegan

everything within easy walking distance. The island has been an artist's colony for more than 150 years, so you'll see lots of people selling and creating pictures all over the island. I recommend you become one of them.

There is literally a picture everywhere you turn here. In the summer and fall lots of lobstering gear is piled up in the back-yards of the cottages along the shore be-cause the lobstering season on Monhegan doesn't start until December. Walk uphill to get the overall shot of the village and the harbor. If you walk up the hill to the south, toward the lighthouse and ceme-tery, you can get a picture of the village, the harbor, the sea, and Manana Island.

Don't be seduced by the beautiful set-ting and forget to also pay attention to the details. Wild roses grow through weath-ered fences, old lobster buoys hang on old wooden doors, and colorful boats are pulled up on shore with floats or traps or flowers inside.

The Trails

Some 20 trails totaling 17 miles crisscross the island—which means that wherever you want to go, chances are a trail heads that way. The two that are of greatest in-terest to photographers are the one that goes around the south end of the island, and the one that crosses the middle of the island to White Head. There are lots of informal trails on Monhegan, as well, so be sure to follow the marked trails (some-times a bit tricky), and don't be led astray on a trail that goes nowhere. If you find yourself thrashing through brush, you are off the trail. Get one of the island trail maps near the ferry dock to help you find your way, and ask someone if you get con-fused.

The **South Loop Trail (149)** follows the gravel road south through the village, into the woods and then past Lobster Cove, Christmas Cove, over Burnt Head, to White Head. There are views all along this trail, with lots of stuff to photograph, and if the weather is foggy, you may never return. Really, you may never return be-cause the fog gets pretty thick out here, so pay attention, and don't wander off the trail. Near the southern tip of the island is the shipwreck of the *Sheridan*. You can still see her old rusty bones lying on shore hear Lobster Cove like a big, beached metal whale. From White Head the trail follows an old woods road across the in-terior of the island and back to the village. You'll pass the lighthouse on the way, where there are great views of the village and harbor. There is also an interesting museum in the former keeper's house that is worth a visit. The trail is about 2 miles long.

The **North Loop Trail (150)** is less precipitous and a bit shorter than the South Loop. Follow the gravel road north past the old schoolhouse, and turn in the forest at the trail sign labeled #11. This trail quickly enters a tall red-spruce old-growth forest that is a bit magical and very impressive for an island 12 miles out to sea. The last time I visited the Cathedral Forest, there were little gnome homes built of sticks and cones around the bases of many of the trees. You be the judge. The North Loop trail shortly comes out to the coast at the summit of Black Head. From here the trail skirts the edge of the island as it curves around the island to the north. As the trail gets to the west side, there are nice views and potential compo-sitions offshore, where Eastern Duck Island lurks over the closer Seal Ledges.

There are also nice views of the harbor as the trail returns to the village.

The trail to **White Head (151)** is the quickest and easiest way to get to the windward cliffs. The views north and south from the open rocky top are very impressive and very photogenic. On my last visit to White Head, three peregrine falcons were riding the updrafts at my eye level. Come here in the late afternoon for the best light.

The best way to photograph and explore Monhegan Island is to make reservations to stay overnight. Then you'll be able to take advantage of the best light early and late in the day, and you won't have to rush as you explore the island. Otherwise, if you take the earliest arriving ferry and the latest departing ferry, you'll have 8 to10 hours on the island.

Matinicus Island (152)

Matinicus Island is 22 miles from the mainland, so it is the farthest offshore island on the Maine Coast. It is also one of the most inaccessible, with only once-a-month ferry service from Rockland. Consequently, Matinicus is the most remote and most remote feeling of all the islands on the Maine coast.

There are really no tourist facilities on the island other than a small lodge and an even smaller gallery and grocery. About 50 people live on the island, almost all lobstermen. Remember, these are not models waiting for you to photograph them but real people trying to live a quiet (very quiet) life. If you like to photograph wild, lonely places where solitude and wild beauty are all around you, Matinicus is the place for you.

The island is 2 miles long and 1 mile wide, with a gravel road going down the middle of the island. The harbor and village are on the northeast side of the island, and there is a small landing strip (it is possible to charter a small plane here from Owls Head Airport) on the very north end. The interior of the island is part spruce woodland and part wild meadow. The coast is a combination of sloping granite blocks and small cobblestone coves. There are two small sand beaches on the island—one on the north side and one on the south side.

Five miles south of Matinicus Island are **Matinicus Rock (153)** and **Seal Island (154),** a wildlife refuge dedicated to the reintroduction of puffins and other seabirds to the Gulf of Maine. While you can't land on this tiny islet, it is possible to see the birds. Photographing them well is another matter though, because generally you can't get close enough, and the sea is seldom calm enough for your best picture-taking. It is a scenic trip, though, and you'll be seeing part of the Maine coast that most people never see. Boat operators run out of New Harbor and Rockland.

Vinalhaven Island (155)

Vinalhaven Island is the largest island on the Maine coast. On the very northern tip of the island is the little, but very quaint, village of **Vinalhaven** built on the edge of **Carver's Harbor,** home of the largest lobstering fleet in Maine. There's a strong year-round community here and an equally strong tourist onslaught in the summer. This is old-time Maine at its best, a truly fun place. You're gonna like it here, whether you take a picture or not.

Like the other islands, a majority of Vinalhaven Island is sparsely populated, mostly wild, and best explored on foot or

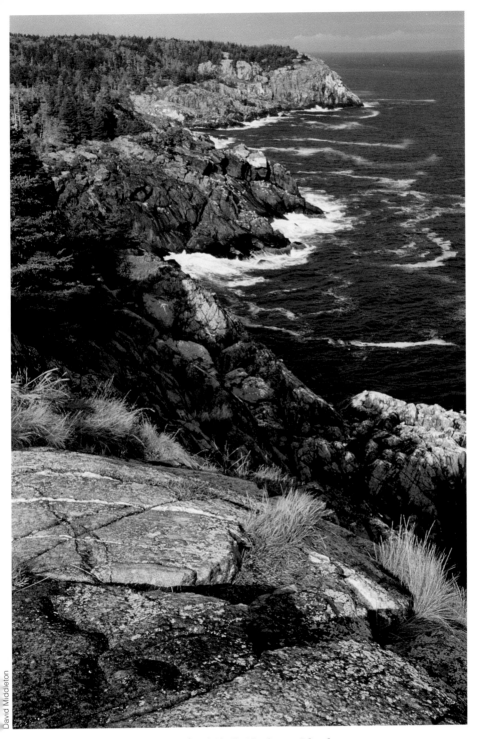

White Head Trail, Monhegan Island

by bicycle. Unlike the other Maine islands, it is possible to drive a car on Vinalhaven because there is frequent daily service to the island from Rockland. But think twice about taking a car here. It will only be a huge hassle, and you'll miss things you would see on foot.

I think the reason to go to Vinalhaven is to explore the village and the harbor. The interior of the island is not any more interesting than forests anywhere along the coast. The village has a strongly Victorian feel, and there are lots of slice-of-pie-Americana photo opportunities here. Walk the back streets, too, to see all the picture possibilities. The harbor faces southeast, so you'll have good opportunities for sunrise but better ones for sunset.

There are lots of parcels of protected land on the island; some are forested, some are meadows, and some are coastal. It is best to get a map to these preserves when you get off the ferry. The closest protected area is the 45-acre **Lane's Island Preserve** on the south side of the island. Turn right through town and then right again to cross the Indian Creek Bridge, and the preserve will be on your left. There is a nice marsh, some wild fields, and a pretty beach to explore. It's about a 15-minute walk from the ferry dock to the preserve.

Isle au Haut (156)

Isle au Haut is an almost mystical place in Maine coast lore. It has been praised in songs, poems, and novels and is a common subject for painters of the Maine coast. The reason is simple: Isle au Haut is really, really pretty. The catch is that you have to be as much of a hiker as a photographer to really see the island. This is why, despite its beauty, most pho-

tographers shy away from here. But if you are the intrepid type you'll be rewarded as you explore this magical island.

One reason why it's so pretty is that it's hard to spend much time here. This is because it is part National Park property, and the park service tightly controls the number of daily visitors and restricts how they get there. Despite all this, it is a magnificent island. Any photographer will get unique Maine coast pictures if they visit Isle au Haut.

The island is about 6 miles long and 3 miles wide and sits about 8 miles off Stonington on Deer Isle. It is the hilliest of all the Maine islands, making it challenging to explore but wonderful to photograph. This is especially true when photographing it by boat, the way I think is the best way to capture it on film. Several boat operators offer sightseeing trips around Isle au Haut out of Stonington Harbor.

There is a daily (except Sunday) year-round ferry service to the north, private end of the island and a summer mail boat service to the south, national park end of the island. Unfortunately, the mail boat arrives at 11 AM and leaves at 6 PM, so you would miss all the pretty light. There is one very small inn on the island (three rooms); otherwise, there are five lean-tos on the island for campers that are by reservation only.

The daily ferry arrives at the town landing near the northern end of the island on its west side. A park ranger generally meets the boat to orient visitors and pass out maps of the island. A 12-mile, partly paved road loops around the island; the interior of the island and its southern tip are accessed by a network of foot paths. There are a total of 18 miles of trails on the island.

Recommendations: With fog, these islands go from pretty to pretty extraordinary. You won't have to walk 100 feet to find terrific pictures. On bright, sunny days I wouldn't bother to go out to the island unless I wanted a break from the tourists and a nice place to go for a walk. This also is true for visiting Monhegan and Vinalhaven in July and August—on a typical day there are just too many people. Not enough people know about Matinicus and Isle au Haut, so crowds are never a problem there.

The best time to go to the islands is either in June, September, or October, when the weather is still nice, and the hordes have gone home. June is when the wild roses and woodland wildflowers bloom, and fall is when the fog rolls and the island shrubs turn color. Fall is also the time when the islands can act as a magnet for migrating birds. I have been out on Monhegan Island when it seemed every bush was alive with resting songbirds. This makes for relatively easy bird photography if you catch a good day.

Pro Tips: The trickiest part of photographing a foggy scene is getting the correct exposure. Most of the time pictures taken in fog will be dark and underexposed. Fog is, in fact, light and airy, and if you underexpose it, the magical etherealness of the scene will disappear. The way to get the proper exposure is to meter a blank hunk of fog and purposely overexpose it—make your light meter read one stop overexposed. What you are doing is adding back the light the camera is trying to take away. When you do this, your pictures will be light and airy, and your foggy scenes won't look dull and dreary.

Be ready to photograph as soon as you get on the boat on the mainland because

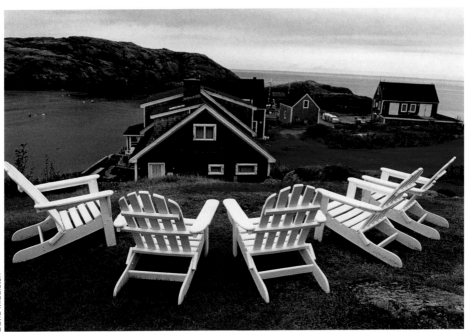

David Middleton

View from the top, Monhegan Island

out to sea. To quote from the Monhegan pamphlet: "No one has been saved who has gone overboard on the south or east sides of the Island." That just about says it all.

The two things to be aware of on an island trip are not getting lost and not missing the last ferry back. You can't get too lost on an island, but you can get lost enough to spend an uncomfortable night outside and certainly turned around enough to miss your ferry. Every island has good maps readily available to help you get around, so be sure to take one, and follow it closely.

On the more remote islands you should also be careful not to hurt yourself by doing something stupid, because if you do, you may not be found until the next tourist season. The cliffs and ledges sometimes look tempting to scramble around on to get a better vantage point, but remember: You are not as young as you used to be, so be careful.

There are places on the islands where poison ivy is thick; if you are sensitive to it, keep your wits about you when you decide to sit down for a picture or a picnic. Also don't smoke on any of these islands. There are no places to dispose of your cigarette butts, and the danger of a catastrophic fire is always very high.

Diversions: There is a nice museum in the keeper's house next to the lighthouse on Monhegan and an equally nice museum in the old town hall in Vinalhaven. Monhegan and Vinalhaven are also meccas for artists of all kinds, and there are galleries on the main streets and side streets on both islands. Vinalhaven has a couple of old stone quarries that are now summer swimming holes.

Monhegan dwelling

Bruce H. Morrison

there will be pictures as soon as the boat pulls away from the pier. Look back toward the ferry dock for shots of the village, and be aware of photo opportunities as the ferry passes close to moored boats. The offshore islands you pass on the way can also be very photogenic. If you are lucky, you'll see whales on your trip out to the island. The best chance is to see harbor porpoises riding the bow wave (always stand in the bow), but you also have a chance to see minke whales and maybe even a finback whale.

Cautions: Just in case you are contemplating taking a swim in the cold North Atlantic, don't do it on any of the seaward coasts (the south or east) on any of the islands. There are bad currents and rips, and you will not be happy if you are swept

IX. Down East

SEASONAL RATING: SPRING ★ SUMMER ★ ★ ★ FALL ★ ★ ★ WINTER ★ ★

General Description: The "Down East" area is found east of Mount Desert Island and consists of Washington County and Eastern Hancock County. Some people call this area the "Sunrise Coast" because as the easternmost section of the United States, the rising sun first illuminates this coast before the rest of the country. The West Quoddy Head Light is on the easternmost point in the United States.

Directions: Route 1 follows the coast from Ellsworth to Lubec. Most of the included sites are accessed from roads that loop off Route 1: The Schoodic Peninsula is accessed from Route 186, Jonesport is on Route 187, and Cutler is on Route 191. East of Lubec is New Brunswick, Canada.

Specifically: East of Mount Desert Island, much is the same but also much is different about the coast. Geographically, this section of the Maine coast offers similar features found along other parts of the coast: rocky shoreline, fingers of land jutting into the ocean, and protected harbors. What *is* different on this part of the coast are the many blueberry barrens that offer photographers ripe berries in August and brilliant red colors in the fall. The big difference between "Down East" and the rest of the Maine coast is the wildness, the lack of development, and the scarcity of tourists.

Schoodic Peninsula (157)

Not all of Acadia National Park is on Mount Desert Island. A small but ruggedly beautiful part of the park occupies

> **Where:** East of Ellsworth and Acadia National Park
> **Noted For:** Old-time Maine and wild unspoiled coast
> **Best Time:** June
> **Exertion:** Easy walking to light hiking
> **Peak Times:** Spring: mid-May; summer: June; fall: mid-October; winter: December
> **Facilities:** At developed sites
> **Parking:** In lots
> **Sleeps and Eats:** A few in each little town
> **Sites Included:** Schoodic Peninsula (of Acadia National Park), Schoodic Head, Corea, Petit Manan National Wildlife Refuge, Blueberry Country, Jonesport, Beals Island, Great Wass Island Preserve, Puffins and Machias Seal Island, Lubec, and West Quoddy Head Light

the oceanside tip of the Schoodic Peninsula on the eastern side of Frenchman Bay. Schoodic Point has a completely different feel to it than the more developed, commercial, and busier part of the park across the bay. People say that this is how Mount Desert Island used to be 100 years ago.

A one-way park road traces the wild shoreline of the peninsula. This point of land, which is the only mainland section of Acadia National Park, consists of 2,000 acres and is accessed by a 7-mile, one-way road that loops around the point. The road runs along the shoreline and offers wonderful views of the rocky coast and surrounding coves and islands. Photo opportunities abound here, in good or bad weather and high or low tide.

There is also a short but somewhat

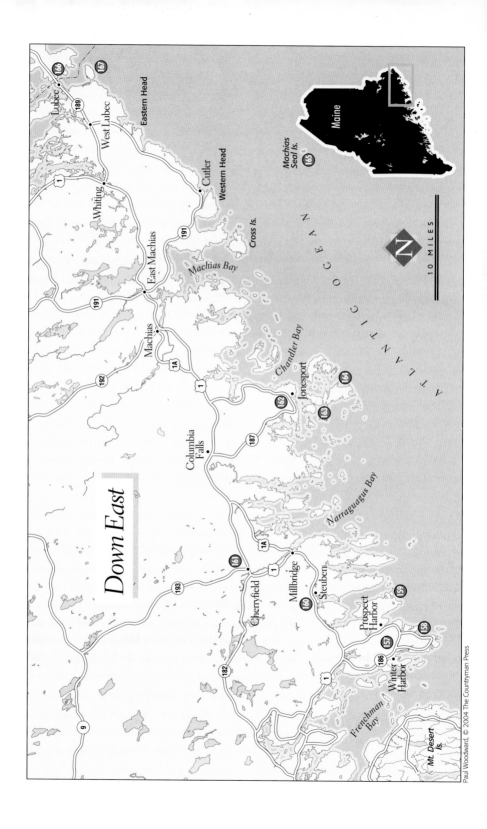

Down East

166 167

Lubec

189

West Lubec

Eastern Head

Whiting

1

Cutler

Western Head

191

East Machias

Cross Is.

Machias Bay

191

Machias

192

1A

1

187

Columbia Falls

162

Jonesport

Chandler Bay

163

164

Narraguagus Bay

1A

161

1

Cherryfield

Millbridge

160

Steuben

193

182

Prospect Harbor

159

158

157

186

Winter Harbor

1

Frenchman Bay

Mt. Desert Is.

9

Machias Seal Is.

165

Maine

ATLANTIC OCEAN

N

10 MILES

Paul Woodward, © 2004 The Countryman Press

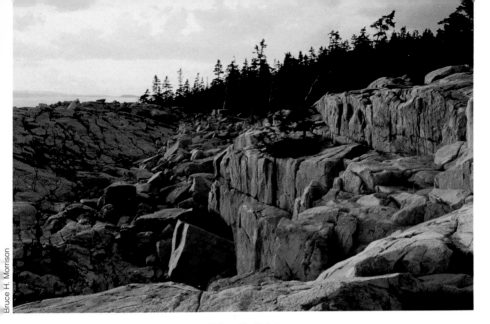

Schoodic Point

steep hike up **Schoodic Head (158)** in the middle of the peninsula. From the top there are fantastic views of Frenchman Bay, the mountains of Acadia National Park, the Down East coastline, and, on the clearest of days, even Mount Katahdin. Morning is the best time to photograph from the top of Schoodic Head.

Directions: The Schoodic Peninsula is reached by driving south onto Route 186 from Route 1 in Gouldsboro. Just as Route 186 passes through Winter Harbor, a sign leads photographers to the Schoodic Peninsula.

Corea (159)

Photographers will be interested in visiting the small village of Corea and its traditional working harbor. The picturesque harbor offers safe moorage to a fleet of colorful lobster boats and dozens of fantastic compositions for photographers. There are also lobster traps and buoys plus other lobster and fishing gear spread over the docks. Fish houses and lobster shanties sit on the shoreline and complete the artistic scene.

Directions: To reach Corea, drive to the village of Prospect Harbor on Route 186, and turn east onto Route 195. Corea is at the end of Route 195.

Petit Manan National Wildlife Refuge (160)

Steuben is the first village encountered as Route 1 heads east from the Schoodic Peninsula. Why is that important? Steuben is the home of the Petit Manan National Wildlife Refuge, one of the wildest parts of the entire Maine coast. The refuge is in two parts: a mainland section that is easily explored and several islands that are closed to the public. The islands support most of the big wildlife, but the mainland has most of the beautiful scenery.

The 2,000-acre mainland part of the refuge offers visitors two loop trails for wildlife and scenic viewing and photogra-

phy. The 1.5-mile Hollingsworth Trail loop heads out through a spruce-fir forest to the coast. A walk along the shore will reward photographers with lots of coastal images. The Birch Point Trail is 4 miles long and winds through blueberry fields, forests, and salt marshes. Those who feel like carrying telephoto equipment have opportunities for some bird photography (more than 250 bird species have been identified on the refuge) along this trail.

Directions: The parking areas for the two trails are found down the Pigeon Hill Road off Route 1 in Steuben. The parking area for the longer trail is a little over 5 miles down the Pigeon Hill Road and the Hollingsworth Trail parking area is another half mile further down the road.

Blueberry Country (161)

Cherryfield is the center of the region's blueberry industry, and two roads lead explorers out through the region's scenic blueberry barrens. Route 193 heads inland for 21 miles. Route 182 travels westward until it eventually reconnects with Route 1 a few miles east of Ellsworth. In August the barrens burst with the ripening berries, while the fields turn a brilliant red in September and October. Route 182 also skirts several very pretty ponds and small lakes to add some variety to your photography.

Directions: Cherryfield is at the Junction of Routes 1, 193 and 182, about half-way between Ellsworth and Machias.

Jonesport Area

Jonesport (162)

This a working harbor packed with lobster and fishing boats. It is also a very scenic harbor, studded with islands and lots of potential pictures.

Beals Island (163)

The largest of the near islands, Beals Island sits in the middle of the harbor and is connected to the mainland by a road over a narrow causeway.

The port is fairly large, and there are many places to find lobster pots and other gear piled on docks. From the town and its docks, photographers can compose nice images of the harbor looking south toward Beals Island in the bay. A quick trip across the causeway to Beals Island will produce images looking back across the water toward the town of Jonesport. You can photograph all day long from the causeway.

Great Wass Island Preserve (164)

The drive to Beals Island provides energetic photographers a chance to explore the Nature Conservancy's 1,579-acre Great Wass Island Preserve. Because Wass Island sticks so far out into the ocean, it's heavily affected by maritime influences. In fact, the island represents the meeting point of the waters of the Bay of Fundy and those of the Gulf of Maine. You'll find twisted trees, dense moss mats, and unusual congregations of plants that are rare elsewhere on the coast.

Two trails provide access to the preserve and originate from the parking lot. The shorter trail, **Mud Hole Trail,** veers to the left and up some rocky ledges and follows a long cove for 1.5 miles through the maritime forest. The trail soon reaches the rocky coast and offers wonderful views of Eastern Bay. **Little Cape Point Trail** proceeds to the right and traverses a spruce-fir forest, eventually leading hikers through several rare coastal bogs. At the

2-mile mark the coast is reached, and again many spectacular views of the surrounding water are found.

The ecology of the island is very diverse but also very fragile, so hikers are asked to stay on the trails and not harm the environment in any way. Since there are plenty of subjects to photograph from the trail, this is not too much of a hardship.

Directions: Jonesport is at the southern end of the Route 187 loop that connects with Route 1 a bit east of Columbia Falls and a few miles west of Machias. Wass Island is reached by bearing left off the causeway through Beals Island and continuing to Wass Island. Follow the road (which turns to dirt) about 2 to 3 miles to the parking area on the left.

Puffins and Machias Seal Island (165)

All photographers who come to the Maine Coast want to photograph puffins. They may not know it, but as soon as they see the many puffin images plastered all over the coast, they will begin to lust after images of their own. Puffins are just so darn cute, they are truly irresistible—especially to photographers. Capturing them on film is actually pretty easy. You just have to know the routine.

Atlantic Puffins spend most of the year out to sea, but from May to August, they arrive on offshore islands to nest and breed. The most densely populated puffin colony is found on Machias Seal Island, located about 10 miles from the mainland. The Canadian government maintains a lighthouse here and keeps a wildlife biologist on the island during the nesting season. Razorbill auks, Arctic terns, and common murres also breed on

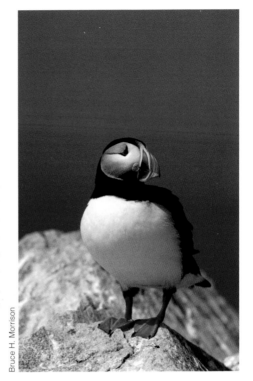

Bruce H. Morrison

Atlantic Puffin

the island and are possible to photograph.

Norton of Jonesport leads daily puffin-watching tours from May through August—weather permitting. The trip out takes around 90 minutes, and visitors spend about 3 hours on the island. Visitors have to be in blinds, but the blinds are strategically situated for prime viewing and photographic purposes, so it's no hardship to stay inside. Once visitors are settled in the blinds, the puffins return to their normal routine and can be spotted 5 feet from a blind and even heard scampering on the roof.

The boat trip departs Jonesport at 7 AM, so an overnight stay in the area is necessary. This is a must trip for any bird photographer. Bold Coast Charter Company also leads trips to Machias Seal Is-

Old sardine processing plant, Lubec

land from the village of Cutler. The boat trip to the puffins is shorter from Cutler, but Cutler is a longer drive to get to.

Lubec (166)

Lubec is the easternmost town in the United States and offers marvelous scenes for camera enthusiasts. Lots of activity occurs in the harbor. Lobster and fishing boats cruise through the waters, either going to or coming from the sea. Colorful sunsets light up the sky and the waters of Johnson Bay.

The breakwater near the town dock provides a good place to set up a tripod for nice sunset photos. From this spot a good photo of the Mulholland Light, which stands on Campobello Island just across the Lubec Channel, can be taken. At one point Lubec was the largest sardine-processing area in the country.

An old sardine-processing building still stands overlooking the Lubec channel between the bridge and the breakwater. The dilapidated, weather-beaten structure yields some nice graphic images.

The most famous structure in the area is the **West Quoddy Head Light (167).** The red-and-white candy-striped building stands on **West Quoddy Head,** the easternmost point in the United States, and is surrounded by **Quoddy Head State Park.** You will not want to miss this lighthouse. It stands on a point with dramatic views, and the colorful stripes will really pop out in your photographs.

A number of vantage points are available for photographers. The view down the path from the parking area shows the lighthouse with a background of the sea. A walk along the coastal trail provides the opportunity to hike down to the water's

edge or walk out on some rocky ledges. Both of these vantage points give photographers a foreground of the coast beneath the lighthouse.

Recommendations: Yes, I know that the Down East coast is a long way from wherever you are, but you should make an effort to go there—especially if you've been to the coast before. Ellsworth is about 6 hours from Portland, so it takes a day to get to anywhere Down East if you start from Down West. On the other hand, if this is your first visit to the Maine coast, you would do better to go to the more visited parts of the coast, where the compositions are more obvious, and the traveling is more comfortable.

Pro Tips: On Machias Seal Island the puffin blinds are small, and while they can accommodate three or four people, they can be confining. Tripods may prove awkward, especially if there is more than one in a blind. Photographers might consider an alternative support, such as a beanbag, or use image stabilization lenses. Often the puffins are so close that a long telephoto lens isn't necessary, although it is handy for birds perched on the rocks farther away. An 80–200mm lens or a 300mm lens is usually perfect.

Cautions: Hiking trails Down East are not easy. They are hilly (sometimes steep) and travel over rocky terrain that's often rutted with roots, as well. The damp locale can also create very slippery conditions on trails. The weather often changes rapidly along the Down East coast, and hikers may start out in sunshine and soon find themselves engulfed in dense fog. Along with the usual warning of wearing sturdy boots, bringing water, and carrying insect repellant, photographers must be prepared for the elements here.

Depending on the weather, the trip out to the puffins may be bouncy and rolling. Those with tendencies toward motion sickness should take precautions. You don't want to be ill while photographing the puffins.

Diversions: If you are here in early July, be sure to stick around for the Fourth of July. The annual Jonesport Fourth of July lobster boat race to crown the fastest lobster boat in the world is a very fun event with lots of picture possibilities.

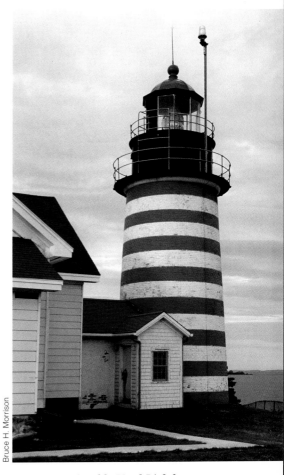

Bruce H. Morrison

West Quoddy Head Lighthouse

X. Favorites

Favorite Traditional Harbors

1. Stonington
2. Friendship
3. Corea
4. Vinalhaven
5. Winter Harbor
6. New Harbor
7. South Bristol
8. Bernard
9. Rockport
10. Five Islands
11. Cape Porpoise
12. Owls Head

Favorite Sailboat Harbors

1. Camden
2. Boothbay
3. Pemaquid
4. Damariscotta
5. Kennebunkport
6. Bar Harbor
7. York Harbor
8. Christmas Cove

Favorite Rocky Coasts

1. Pemaquid
2. Schoodic Point
3. Monhegan Island
4. Otter Cliffs, Acadia National Park
5. Christmas Cove
6. Isle au Haut
7. Cutler Coastal Trail
8. Wonderland, Acadia National Park
9. Reid State Park
10. Portland Head Light

Favorite Eats

1. The Goldenrod, York Beach
2. Hattie's Deli, Biddeford Pool

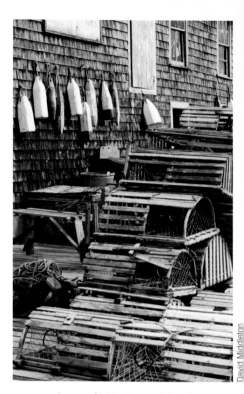

David Middleton

Bernard: Mt. Desert Island

3. Sarah's, Wiscasset
4. Shaw's Bar & Wharf, New Harbor
5. Moody's Diner, Waldoboro
6. Primo's, Rockland
7. Market Basket, Rockport
8. Red's Eats, Wiscasset
9. The Waterfront, Camden
10. Cherie's, Kennebunk
11. Muscongus Bay Lobster Co., Round Pond
12. Harraseeket Lunch & Lobster, South Freeport

Favorite Villages

1. Camden
2. Monhegan
3. Damariscotta
4. Wiscasset
5. Port Clyde
6. Winter Harbor

7. Vinalhaven
8. Rockport
9. Ogunquit
10. Northeast Harbor

Favorite Lighthouses

1. Pemaquid Point Light
2. Nubble Light
3. Portland Head Light
4. Bass Harbor Light
5. Marshall Point Light
6. West Quoddy Head Light
7. Rockport Breakwater
8. Owls Head Light

Favorite Sunrise Locations

1. Pemaquid Point
2. Lincolnville
3. Boulder Beach, Acadia National Park
4. Cadillac Mount, Acadia National park

5. Rockport Harbor
6. Friendship
7. Round Pond Wharf
8. South Freeport Wharf
9. Stonington
10. Five Islands
11. Bass Harbor Light
12. Portland Head Light

Favorite Sunset Locations

1. Cadillac Mountain, Acadia National Park
2. Friendship
3. Stonington
4. Merrymeeting Bay
5. Bass Harbor Light
6. Portland Head Light
7. Port Clyde
8. West Quoddy Head Light
9. Schoodic Point
10. Cape Neddick

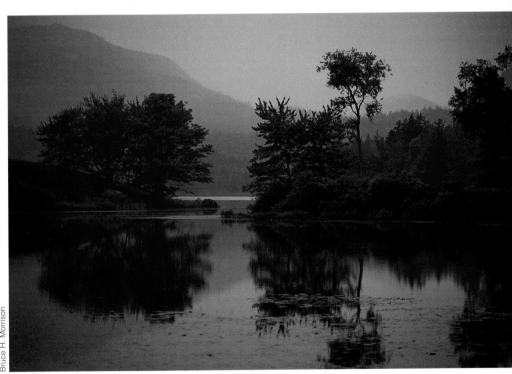

Bruce H. Morrison

Tranquil Acadia

Port Clyde

3. Route 102A, Acadia National Park
4. Schoodic Peninsula
5. Route 24, Orrs and Bailey Islands
6. Route 209, Phillipsburg
7. Route 130, Pemaquid
8. Route 9, Kennebunkport

Personal Favorites

1. Camden Harbor
2. Jordan Pond
3. Stonington
4. Nubble Light
5. Christmas Cove
6. Monhegan Island
7. Friendship
8. Pemaquid Point
9. Cadillac Mountain, Acadia National Park
10. Ogunquit
11. Rockport Harbor
12. Portland Head Light

Most Published Maine Coast Images

1. Portland Head Light
2. View from Cadillac Mountain
3. Belted Galloways, Camden
4. Pemaquid Point Light
5. L.L. Bean
6. Camden Harbor
7. Puffins
8. Windjammers
9. Jordan Pond with the Bubbles
10. Nubble Light

Favorite Scenic Drives

1. Park Loop Road, Acadia National Park
2. Route 15, Blue Hill area

Virginia creeper, Monhegan